History of Industrial Gravure Printing up to 1920

Otto M. Lilien

History of
Industrial Gravure Printing
up to 1920

Lund Humphries London

Copyright © 1972 by Otto M. Lilien

First English edition 1972
Published by
Lund Humphries Publishers Limited
12 Bedford Square London WC1

SBN 85331 321 0

Made and printed in Great Britain by
Lund Humphries, Bradford & London

The publishers acknowledge with thanks
the co-operation of
Druckfarbenfabrik Gebr. Schmidt GmbH,
Frankfurt, in making available the blocks
from the German edition.

Contents

Preface

It all started in 1953 when my husband was Technical Adviser to the Government Printer of Israel for the production of postage stamps under the auspices of the United Nations Technical Assistance Administration.

The first gravure stamp was produced in honour of the VIIth Congress for the History of Science which took place in Jerusalem. A friendship developed with the President of the Congress, the late Professor Fritz Bodenheimer. The following year he visited us in England and suggested to Otto that he should read a paper on the History of Gravure Printing at the History of Science Congress at Florence.

In the beginning, writing the paper seemed easy, because it was believed that the history was well documented in trade publications and manuals of printing. Soon, however, it became obvious that most writers had copied one and the same source which appeared not to be very reliable. So it turned out that deep research was necessary to write the true history of the beginnings of gravure printing.

Only the very barest outlines were touched upon in the paper read at Florence, but once started, Otto went deeper and deeper into the matter. He started a world wide correspondence which resulted in many a good find and hints as to where more information might be obtainable. We undertook extensive travels in England and on the Continent to talk to people connected in any way with the early developments and to look for documents, patents, and blueprints of printing presses.

It took nine years to collect the data for this book and a large number of unique documents on early gravure came into our hands.

Our old friend Dr Martin Hartmann interested Herr Werner Schmidt of Gebr. Schmidt, ink manufacturers at Frankfurt, in this fascinating story. Gebr. Schmidt published the history in two volumes to be given to their friends and customers.

The English edition has been rewritten and slightly enlarged using material which has come to light since the publication of the German edition.

A large collection of original documents, early prints, letters, drawings and books came together during the years. It was acquired by Werner Schmidt and presented to the Gutenberg Museum at Mainz. The 'Tiefdruck Geschichtliche Sammlung Otto M. Lilien' (Gravure Historical Collection O.M.L.) as it is called, is freely available to researchers and students of the history of gravure printing.

At present the author is collecting material and information to take the history of gravure developments up to 1970.

L.L.

The early history up to 1800

Every day an endless stream of printed products threatens to drown the world. Details of the technical development which was required to make this possible are practically unknown, because the development of modern printing techniques has been very much neglected by the scholars of the history of technology. There are many histories of printing in all languages. They, however, deal predominantly with the printed product. They discuss the printed book, the page, the illustration, type or layout, but very rare are publications on historical investigations into the technical development of the printing processes, the printing presses, or the production of printing surfaces.

From time to time text-books on printing contain short chapters on the history of the preparation of the printing surface in the old craft establishments. The names and methods of the early printers are well known. One can read of woodcuts, etchings, engravings, and other older techniques. In many museums one can study the original prints and there are documents and information on the craftsmen and their methods in the early days of printing.

But when these descriptions reach the end of the nineteenth century, the time of the Industrial Revolution when manual work of the individual craftsman began to be encroached upon by mass production, then we can find only very sparse and unreliable reports regarding the further development of printing technology.

More and more of the technical development is described with only sketchy details and it is noticeable that the references are often missing. Frequently the information contradicts itself regarding the person credited with inventions and technical improvements.

These facts have made it particularly difficult to describe the development of gravure in an historical essay, which is well documented. The present work aims to fill this gap and to supply such information to the friends of gravure and printing. It is hoped that it will be an interesting and reliable contribution to the history of technology.

Josef Maria Eder,[1] who for many years was the director of the famous Viennese College of Printing (Graphische Lehr- und Versuchsanstalt), has written a *Handbook of Photography*[2] in sixteen volumes. In the first two volumes of this extensive set of books, called *History of Photography*, he deals in detail with the early development of gravure. His attempt at a critical history contained in these two volumes, as well as in a number of historical chapters in the subsequent technical volumes of his handbook, suffers, however, from a lack of objectivity. From time to time it is obvious that his description of the development of printing technology is hampered by serious prejudices.

J. S. Mertle has published a long series of articles dealing with the history of gravure in the American trade paper *Gravure*.[3] He says that the mention of engraving goes back to prehistoric cave dwellers. He cites John Jackson who, in *A Treatise on Wood Engraving*,[4] says on page 7: 'At a very early period stamps of wood having hieroglyphic characters engraved on them were used in Egypt for the purpose of producing impressions on bricks and on other articles made of clay.'

Konrad Bauer, in his monumental reference book *Aventur und Kunst*,[5] says that the first engraving on metal used for printing was produced in 1446 and shows a Flagellation of Christ. Alexander Braun, in his book *Der Tiefdruck, seine Verfahren und Maschinen*,[6] has published a picture of this important engraving.

The anonymous *Sculptura-Historico-Technica*[7] appeared in London in 1747 and states that the Florentine goldsmith Maso Finiguerra engraved a silver plate for Niello in 1452 and pulled a print from the plate on paper, to see if the engraving was satisfactory. The plate still exists and is preserved in Florence. An old print of this plate, which may have been taken by Finiguerra himself, is preserved in the Bibliothèque Nationale in Paris. The picture[8] shows a *Crowning of the Virgin Mary* (Fig.1).

After the invention of etching, in which a drawing is incised into a metal surface by the action of a mordant, several authors ascribe this invention to different inventors. Bauer[5] says that the armourer and engraver, Daniel Hopfer in Augsburg, was the actual inventor and cites 1505 as the year of the first etching. But carefully he adds that the first dated print was made in 1513. It is an etching by Urs Graf reproduced by Mertle.[3] The *Sculptura-Historico-Technica*, on the other hand, ascribes the invention of etching to Franco Mazzuoli, called Parmigiano (1504–40).

During the next hundred years a large number of various methods for the production of copper engravings were described.

In 1719 James Christopher LeBlon,[9] born in Frankfurt-am-Main, received a British patent for 'A new Method of multiplying Pictures and Drafts by a

natural Coloris with Impression'. LeBlon, who lived in Frankfurt, London and Paris, called himself according to his abode from time to time: Jacob Christoph, James Christopher or Jacques-Christophe LeBlon. His patent[10] described the production of natural coloured pictures by superimposing three mezzotint printings in yellow, red, and blue. LeBlon was born in 1670 or 1667. In Gwinner's book *Art and Artists in Frankfurt-am-Main (Kunst und Künstler in Frankfurt-am-Main)*, which appeared in 1862, it is stated that LeBlon was baptized in Frankfurt on 23 May 1667. LeBlon was a pupil of the famous

1. *Crowning of the Virgin Mary.* Print from a Niello plate by Maso Finiguerra, Florence, 1852. Actual size. Original in the Bibliothèque Nationale, Paris.

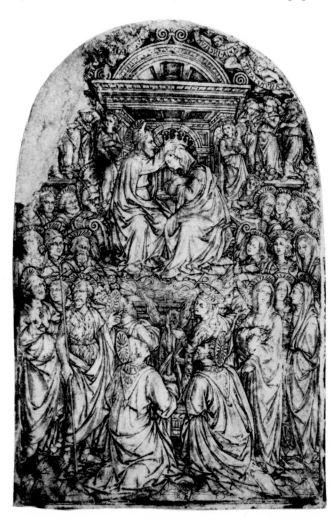

engravers C. Meyer in Zurich and A. Bosse in Paris. In 1696 and 1697 we find
him working under C. Marath in Rome. Following activities in Rome and
Amsterdam as a gifted producer of mezzotint prints, he came to London and
produced coloured mezzotint portraits in seven colours. His early use of seven
colours was based on the colour theory published by Sir Isaac Newton in
1704. About 1718 he succeeded in achieving acceptable results using only three
colours. A company founded in London for the exploitation of his patent had
a limited financial success for a few years, but subsequently went bankrupt
and LeBlon was forced to go to live in Paris in 1737.

In Paris he produced several important three-colour prints, notable among
which is a life-size portrait of Louis XV, which he finished before he died in
Paris in 1741. In 1722 LeBlon published in London a book *Coloritto*[11] in which
the following statements can be found (Fig.2):

'Painting can represent all visible Objects, with three Colours, Yellow,
Red, and Blue; for all other Colours can be composed of these Three,
which I call Primitive; for Example:

Yellow
and } make an Orange Colour
Red

Red
and } make a Purple and Violet Colour
Blue

Blue
and } make a Green Colour
Yellow

'And a Mixture of those Three Original Colours makes a Black, and all
other Colours whatsoever; as I have demonstrated by my Invention of
Printing Pictures and Figures with their natural Colours.

'I am only speaking of Material Colours, or those used by Painters; for a
Mixture of all the primitive impalpable Colours, that cannot be felt, will not
produce Black, but the very Contrary, White; as the Great Sir Isaac Newton
has demonstrated in his *Opticks*.

'White, is a Concentering, or an Excess of Lights.

'Black, is a deep Hiding, or Privation of Lights.

'But both are the Produce of all the Primitive Colours compounded or
mixed together; the one by Impalpable Colours, and the other by
Material Colours.

'True PAINTING represents

1. Lights by White.

2. Shades by Black.'

COLORITTO
OR THE
HARMONY
OF COLOURING IN PAINTING,

Reduced to Mechanical Practice, under easy Precepts, and infallible Rules.

Of Preliminaries.

COLORITTO - *or the Harmony of Colouring, is the Art of Mixing* COLOURS, *in order to represent naturally, in all Degrees of painted Light and Shade, the same* FLESH, *or the Colour of any other Object, that is represented in the true or pure Light.*

L'HARMONIE
DU COLORIS
DANS LA PEINTURE.

Et réduite en Pratique méchanique, & à des Régles sûres & faciles.

Instructions Préliminaires.

LE Coloris, *dans la Peinture, est l'art de mêler les Couleurs pour représenter dans tous les degrés des Lumières & des Ombres peintes, la même Chair, ou quelqu'autre Objet, tel que la Nature le représente.*

PAINTING can represent all visible Objects, with three Colours, Yellow, Red, *and* Blue; *first all other Colours can be compos'd of these Three, which I call Primitive; for Example.*

Yellow
and } *make an* Orange *Colour.*
Red

Red
and } *make a* Purple *and* Violet
Blue *Colour.*

Blue
and } *make a* Green *Colour.*
Yellow

And a Mixture of those Three Original Colours makes a Black, *and all other Colours whatsoever; as I have demonstrated by my Invention of Printing Pictures and Figures with their natural Colours.*

La Peinture peut représenter tous les Objets visibles avec trois Couleurs, sçavoir le *Jaune,* le *Rouge* & le *Bleu;* car toutes les autres Couleurs se peuvent composer de ces trois, que je nomme Couleurs primitives. Par exemple,

Le *Jaune*
& } font l'*Orangé.*
Le *Rouge*

Le *Rouge*
& } font le *Pourpre* & le
Le *Bleu* *Violet.*

Le *Bleu*
& } font le *Verd,*
Le *Jaune*

Et le mélange de ces trois Couleurs primitives ensemble produit le Noir & toutes les autres Couleurs, comme je l'ai fait voir dans la Pratique de mon Invention d'imprimer tous les Objets avec leurs couleurs naturelles.

I am only speaking of Material Colours, or those used by Painters; for a Mixture of all the primitive impalpable Colours, that cannot be felt, will not produce Black, but the very Contrary, White; *as the Great Sir* Isaac Newton *has demonstrated it his* Opticks.

White, *is a Concentering, or an Excess of Lights.*
Black, *is a deep Hiding, or Privation of Lights.*
But both are the Produce of all the Primitive Colours compounded or mixed together; the one by Impalpable Colours, and the other by Material Colours.

True PAINTING *represents*
1. *Lights by White.*
2. *Shades by Black.*

Je ne parle ici que des Couleurs Matérielles, c'est-à-dire, des Couleurs dont se servent les Peintres; car le mélange de toutes les Couleurs primitives impalpables ne produit pas le Noir, mais précisément le contraire, c'est-à-dire, le Blanc; comme l'a démontré l'incomparable Mr le Chevalier Newton dans son Optique.

Le *Blanc* est une concentration ou Excès de Lumière.
Le *Noir* est une Privation ou Défaut de Lumière:
Mais l'un & l'autre se produit par le mélange des Couleurs primitives; mais l'un résulte du mélange des Couleurs Impalpables, & l'autre des Couleurs Matérielles.

Dans la PEINTURE on se sert
pour représenter
1. Les Lumières..... du *Blanc.*
2. Les Ombres........ du *Noir.*

Eder[12] says that experiments to create tone values with dust grain for intaglio prints and subsequent etching were published for the first time in Nürnberg by Stapart[13] in 1780. This book, however, is only a German translation of an original work which appeared in 1773 in Paris, a copy of which is kept in the Bibliothèque Nationale in Paris.[14]

The methods used so far do not require machinery. In this context the term machinery does not mean equipment which at one preparation only produces one single print, after which all preparations have to be elaborately repeated for the next print, as is the case with simple star wheel presses for the printing of steel engravings. The expression machinery means equipment which can produce continuously and which does mechanically at least some of the required working steps such as inking, wiping, feeding the paper, or the actual impression, which is the marrying of ink and paper.

The first printing press, which was a machine for printing from intaglio formes, is described in detail in the British patent of 1783, granted to Thomas Bell[15] for a textile printing machine. In the following year the same Thomas Bell received a further patent (Fig.3).[16]

The patent drawing and description of this patent of 1784 show a rotary machine, which has all parts in a rudimentary form to be found on present-day industrial gravure presses, used for gravure printing on paper, textiles, or plastics. Minute descriptions and drawings are given of the inking unit, of the printing cylinder and the doctor blade for removing the unwanted ink from the cylinder surfaces, as well as the impression cylinder. The description of the printing cylinders is of particular interest. They are described as having 'centres of iron covered with copper or other metal, which can be taken off at pleasure, and by that means fresh patterns put on as often as required.'

Even more surprising is that the blade for removing the surplus ink from the cylinder surface is described with the term which is used today as 'the doctor blade'.

Such Bell intaglio rotary presses were used in Preston in the famous textile printing works of Livesay, Hargreaves & Co. till this firm failed in 1788.[17] No description has so far been traced of the method used for the production of the printing surfaces required for these presses. In the patents Thomas Bell describes himself as engraver in copper, and one must therefore assume that the designs were hand-engraved using burins and other artists' tools.

The French *Dictionnaire des Arts et Manufactures*, by Mathias, which appeared in Paris in 1847, mentions a book *L'Art de préparer et d'imprimer les étoffes de laine* published in Paris in 1780 by Rolland de la Platière, which is said to state that Bonvalet in Amiens printed textiles by means of printing rollers as early as 1755. Platière does not mention if these printing rollers were relief or

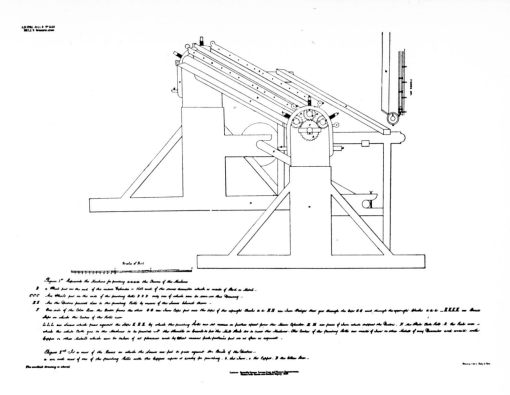

3. Drawing from the British Patent No.1443 of 1784. Thomas Bell. *Method of Printing on Calico . . .*

intaglio. According to Mathias, the same book also mentions that Chandelier had 'decorated' (*'il gaufrait'*) textiles as early as 1680 using engraved rollers, and that such rollers were also used by the widow Savoye in Amiens for the same purpose.

Mathias's dictionary contains a picture and detailed description of a rotary intaglio press for textile printing, which, after the Bell patents, seems to be the oldest description of a gravure printing press.

This interesting picture shows the use of a reversed blade after the impression to remove textile fibres before they can reach and contaminate the ink in the ink duct.

The nineteenth century

During the first half of the nineteenth century a number of basic developments took place, which soon found application in the production of intaglio printing surfaces. Photography was invented and several methods were found to combine regular or irregular grain formations with light sensitive layers for the production of photo-mechanical printing plates.

Eder,[18] Mertle,[3] Gernsheim[19] and many other authors have described the progress in well-documented publications. Only the more outstanding landmarks leading to the present-day technique of cylinder production will be mentioned here.

In 1826 Joseph-Niécephore Niépce[20], 1765–1833, (Fig.4) produced the first photo-mechanical etched printing plate. He covered a zinc plate with light-sensitive bitumen and exposed through a copper engraving, which was made

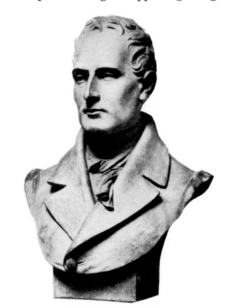

4. Niécephore Niépce 1765–1833.
Terra-cotta portrait bust in the Museum in Chalon-sur-Saône.

5. Print from one of the etched heliography plates by Niécephore Niépce, 1826.
From an engraving of Cardinal d'Amboise.

translucent by the application of oil. After removing the unexposed parts of the bitumen coating by washing in a suitable solvent, the plate was etched and subsequently the shallow etching was deepened by hand engraving. The first printing plates made in this way are a portrait of the Cardinal d'Amboise (Fig.5). Three of these plates are preserved to this day; two are in the museum in Chalon-sur-Saône, the third is in the Science Museum in London.

Mungo Ponton,[21] an English amateur scientist, lived from 1801 to 1880 (Fig.6). In 1838 he described the light sensitivity of mixtures of organic substances with potassium bichromate.[22] He produced photographic pictures on paper which was sensitized in a bichromate solution.

William Henry Fox Talbot[23] (Fig.7), 1800–77, made a large number of basic discoveries relating to photography. The most important of these for the development of the photo-mechanical production of printing plates was the discovery of the light sensitivity of chrome colloids, which he described in 1852.[24] This discovery is the basis for the use of pigment paper or carbon tissue as resist for gravure etching. In the same report, Fox Talbot mentions

6 (below). Mungo Ponton, 1801–80. From a heliogravure by Karel Klic in the Museum of the Royal Photographic Society in London.

7 (below, right). Fox Talbot, 1800–77. From an anonymous heliogravure in the Museum of the Royal Photographic Society in London.

8. Paul Pretsch, 1808–73. From a platino print in the Museum of the Royal Photographic Society in London.

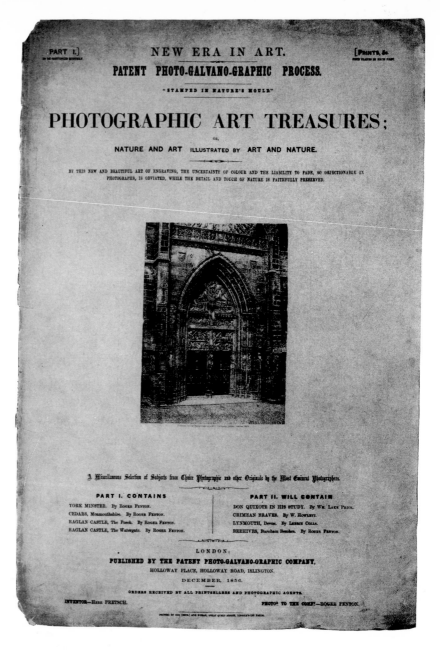

9. Title page of the first part of *Photographic Art Treasures*, by Paul Pretsch. Collection OML.

that one can transform a continuous tone picture into a halftone by interposing a woven textile and make it suitable for the etching of a printing plate.

The Viennese Paul Pretsch[25] (Fig.8), working in London, can claim the credit for producing the first folder of large illustrations using a photo-mechanical reproduction process. He had the idea of printing from intaglio printing plates made by electro-deposition of copper on to gelatine reliefs made by Fox Talbot's method.[26] In 1856 he founded the Patent Photo Galvano Graphic Company in London, which produced large runs of folders called *Photographic Art Treasures* (Fig.9).

Just a year later, in 1857, Alphons Louis Poitevin[27] (Fig.10) produced pictures using chromated gelatine. Finally, in 1858, Fox Talbot received a patent[28] for improvements in the art of engraving, describing an etching technique through a gelatine relief resist using a sequence of iron perchloride solutions of diminishing density.

One cannot really doubt that during all these years engineers, press designers and printers were also working, but no information has

10. Alphonse Louis Poitevin, 1819–82. Museum of the Royal Photographic Society in London.

11. Drawing from the French patent
No.47008 of 1860. Gravure perfecting press
by Auguste Godchaux.

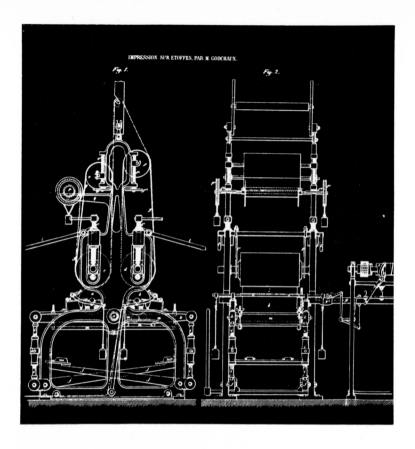

IMPRESSION SUR ETOFFES, PAR M. GODCHAUX.

Fig. 1. *Fig. 2.*

been found regarding progress in the design of gravure presses. Only in 1860 was a French patent[29] taken out by Auguste Godchaux, publisher in Paris, which covers a reel-fed gravure perfector press (Fig.11). Patent drawing and description show a web-fed rotary press having two separate units for printing both sides of the paper, arranged in a way similar to modern machines. Each of the press units resembles gravure units of today. In general layout and also in many technical details the Godchaux press is very reminiscent of the famous and often illustrated gravure perfector press installed in November 1910 by Dr Eduard Mertens[30] at the works of Poppen & Ortmann in Freiburg, Germany. This Mertens machine, which was used from early 1911 for the printing of the gravure illustrations in the *Freiburger Zeitung*, is often erroneously believed to be the first gravure press of practical usefulness (Fig.12).

The Godchaux patent mentions expressly that the press is intended to print

on a paper web. The machine printed on both sides of the web, but was also capable of being used as a sheet-fed machine. The impression roller was a steel cylinder over which an endless felt blanket was led. The printing cylinders were hand engraved. Impression was regulated by screws. A lever arrangement was used for activating the impression throw-off action, moving the printing cylinder up and down together with the ink duct and doctor arrangement. The printing cylinder dipped into the ink in the ink duct; the inking was assisted by two duct rollers. To clean the ink from the non-printing surface area of the cylinder, a doctor blade was used which moved along the cylinder face in the same way as is still the practice today. Doctor blade pressure was regulated by weights acting through levers.

12. Mertens Gravure perfecting press for the *Freiburger Zeitung* built by Société Alsacienne de Constructions Mécaniques in Mulhouse, Alsace.
Collection OML.
Presented by Dr M. Ortmann, Freiburg.

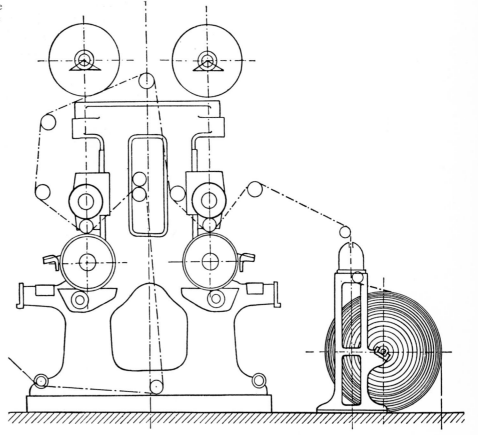

This machine was designed more than 110 years ago and its basic similarity to modern design is surprising to see. But more surprising is the fact that this design was not an inventor's dream only surviving in the files of the Patent Office. There is no doubt that at least two of these machines were built and used on day-to-day production for very many years.

Mertle[31] found in the English trade paper *The Lithographer*, of 7 August 1871, further important details concerning this machine.[32] The paper says:

'Godchaux & Co's machine for printing copy books, etc., is an extraordinary and ingenious machine, which may properly be entitled a cylindrical copperplate printing machine. Both sides of the paper being printed at one and the same operation. The machine . . . is draughted somewhat upon the principle of the calico printing machines . . . The object or characters to be printed are engraved on copper cylinders of about 6 inch diameter and about 24 inches in length . . . The engraving of these copper cylinders . . . is not lined by the graver . . . nor etched with acid . . . but is accomplished by a series of minute little holes hardly discernible by the naked eye, but forming together the outline of the letters . . . to be printed . . . The paper being slightly damped, is made to revolve on the web over these engraved cylinders, the ink being contained in an ink duct in which the cylinders revolve . . . the surface is then cleaned of the superfluous ink by means of a steel scraper or "ductor" . . . scraping the surface of the cylinder and leaving the ink in the engraved parts only. The impression on the paper is got from a counter cylinder covered with an elastic material against each engraved roller . . . It may be added that Messrs Philips, Son & Nephew of Liverpool are the only firm in this country that use this machine.'

A preliminary search of the patent files going back to 1865 did not elucidate any further information. Eventually Mr H. Pickles, works manager of Messrs George Philip & Son Ltd in London, found corroboration in *The Story of the House of Philip during the last 100 years*, by George Philip[33] (1934), in the statement:

'To meet the requirements in other branches of education, the Catalogue of the Firm's publications was further expanded by . . . and by several new series of Copybooks, the sales of which were so large that to keep up with the demand a special quick-running machine costing several thousands of pounds had to be installed in 1867.'

A sample copy, unfortunately undated, of Philip's Home and Colonial Copy Books printed on this press is preserved in The John Johnson Collection of Printed Ephemera in the Bodleian Library in Oxford.

A photograph of the machine is kept in the archives of the Société Alsacienne de Constructions Mécaniques in Mulhouse, which was taken in 1936 in the then

still existing works of Messrs Godchaux in Paris (Fig.13). The photograph's caption reads: 'Rotative Kientzky-Godchaux. Vue d'ensemble de la rotative imprimant recto-verso les célèbres cahiers d'écriture.' ('View of the rotary perfecting press producing the famous school copy books.')

The shirt-sleeved man standing with his back to the camera is the youngest son of the inventor, Marcel Godchaux, who lived in Paris in retirement when the author visited him in 1957. Marcel Godchaux gave the following supporting details: 'My father, Auguste Godchaux, the inventor of the press, died a few months before I was born in 1884. He himself was born in Alsace and worked as a young man in the well-known textile printing works of Oberkampf. In the late 1850's he started his own business in a small workshop in Paris, rue Pastorelle, producing copy books for schools. His firm was very successful and soon had to move into larger premises in rue de la Douane for increased production of the copy books (Fig.14). Soon these premises were

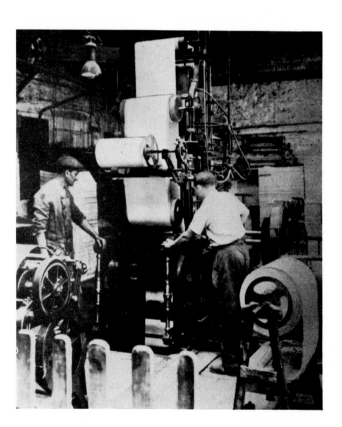

13. Photograph of the Godchaux machine taken in the works of Godchaux & Cie in Paris in 1936. From the archives of SACM in Mulhouse.

14. Title page of a Copy Book printed by Godchaux & Cie on the gravure perfector press about 1880.
Collection OML.

again too small and the final move into larger rooms in the Boulevard Charonne enabled the firm to survive till 1940. The old press of 1860 was in full use till the liquidation of the firm during the German occupation.'

Who Kientzky was – he is mentioned in the caption of the photograph of the press kept at Mulhouse – could not be ascertained. One can only surmise that he was the craftsman who actually made the press.

We must pause here to continue the story of the progress in process work during the second half of the nineteenth century. It is most interesting to trace now the development of the use of the gravure screen used for producing the doctor-carrying grid, which has nothing to do with the gradation formation in the picture, but only serves to support the doctor blade in the etched areas on gravure cylinders. The method of the production of the cylinders for the Godchaux machine is described in the article in *The Lithographer* of 1871. A sample print in the author's gravure historical collection (now in the Gutenberg Museum in Mainz), which he received during his visit to Marcel

Godchaux, confirms the description on inspection under a magnifying glass. In normal depth variable gravure a rectangular crossline system is used covering the printed picture, which does not interfere noticeably with the tone gradation.

M. Bechtold's French patent of 1857[34] describes the printing down of screens on to light-sensitized metal plates. The screen used is a glass plate covered with an opaque layer into which fine lines are inscribed with a sharp point. The screen is twice printed down on to the metal plate turned through 90° between the exposures. A continuous tone diapositive is then exposed and the plate etched as today in a multiple bath procedure.

Josef Wilson Swan's (Fig.15) patent of 1864[35] describing the transfer of gelatine pictures to metal plates completes the detail processes which together are used in combination in modern gravure cylinder production. But the genius has not yet appeared who combined all these detail processes to form the admirable technique of today's gravure.

Karel Klic, or Karl Klietsch as he called himself at different times in his long life (Fig.16), was born in Arnau in Bohemia on 31 May 1841. He was the first to publish small editions of dust grain heliogravures. Karl Albert[36] tries to prove in his biography of Klic that he invented the heliogravure process without knowledge of the experiments of earlier or contemporary workers. Mertle[37] proves that this is really more than unlikely and that Klic, who was a

15 (below). Joseph Wilson Swan, 1828–1914. After a heliogravure owned by Sir Kenneth R. Swan.

16 (below, right). Karel Klic, about 1900. From a photograph owned by Mr Karl Falter, London.

member of the Photographische Gesellschaft in Vienna, frequently heard reports of such work and received many stimuli. Nevertheless Klic was the first not to work on his own in secrecy, but to instruct others, for large fees, in the use of the process which he had developed into a practical method. His own production of prints was limited, but he was well aware of the financial value of his developments. He exhibited some of his prints at a meeting of the Photographische Gesellschaft in Vienna in 1879, but did not publicize his working methods.

It was to be expected that details of his working methods would become known after he sold his process to several Viennese process houses and to Braun in Mulhouse and Annan in England. When Lenhard published complete working details of the Klic method in the *Wiener Photographische Mitarbeiter* of March 1886, Klic was very annoyed and left Vienna for England.

Further developments are still somewhat obscure. Albert[36] reports that without any doubt Klic was well conversant with textile printing before he left Vienna. But how and where Klic came into contact with lino production has not been clarified. Neither is it known why soon after his arrival in England he came into contact with Samuel Fawcett (Fig.17), the process worker of Storey Brothers in Lancaster. Storey Brothers were calico printers, sail makers and producers of American cloth. The firm is still flourishing today.

Samuel Fawcett's grandson, Derek Fawcett, was gravure manager at

17. Samuel Fawcett, 1862–1934. From a photograph owned by W. F. D. Fawcett, Lancaster.

Storey Brothers and told the author in 1957 that his grandfather Samuel lived all his life in Lancaster, from 1862 to 1934. In 1877 he joined Storey Brothers as engraver. He found engraving boring and experimented to speed up the tedious work. He was a keen amateur photographer and after many futile trials he eventually succeeded in combining engraving and photography in the way known today. In 1890 he applied for patents covering photographic inventions, in which he describes himself as a process engraver. Several small examples of gravure experiments printed on paper are in existence, showing the use of single and crossline screens, one of which is even a three-colour trial. All carry a pencil-written date of 1892. These markings must be considered with caution. All these early trials by Samuel Fawcett were printed on commercial cotton printing presses at White Cross Mills in Lancaster. The idea of printing on paper commercially only grew after Klic was engaged by Storey Brothers.

Klic suggested the formation of the Rembrandt Intaglio Printing Company, which started work in August 1895 using reel-fed gravure for the production of art prints, which were to be sold as heliogravures in art shops. There is no doubt whatsoever that all early Rembrandt prints were printed on presses built for textile printing.

It is impossible to establish with certainty if Fawcett or Klic used screens before they started to collaborate. Prints exist in the collection of Fawcett as well as in that of Klic, which is in the Mertle Collection now kept at the 3M Company in St Paul, Minnesota, USA, which prove only that experiments with screens were made in Lancaster after 1890, leading to the use of 150- and 175-line screens for the Rembrandt prints. The statement made by Albert and Eder that Klic designed the presses is certainly a free invention, because before 1905 no special presses had been built for the Rembrandt Company, and in any case a Godchaux press was used in Liverpool. The textile printing machines installed at the White Cross Mill at Storey Brothers were used. They were normal textile printing machines supplied by Joseph Foster & Sons in Preston (Fig.18).

Considering that all this happened less than eighty years ago it is indeed surprising but undeniable that the real facts of the mutual influence the two friends and inventors had on each other, and of which they were not conscious, cannot be unravelled. For example, Albert[36] relates that early in the eighties Klic had tried in Vienna to produce gravure cylinders for textile printing by means of his dust grain heliogravure process. He is said to have made these experiments in the Cosmanos Textile Works near Vienna, but without success.

In January 1892, in the Vienna periodical *Photographische Korrespondenz*, Adolf Brandweiner published an article 'Photographisches Verfahren zur

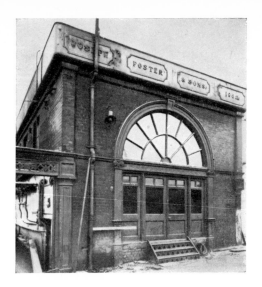

18. Factory building of Joseph Foster & Sons, printing press manufacturers, built in the middle of the nineteenth century. The watertank on the roof was added in 1902. Demolished 1957. Photo supplied by the Goss Printing Press Company Ltd, Preston.

Herstellung von Druckwalzen für Stoffdruck' ('Photographic method for the production of printing rollers for textile printing'). He not only mentions here the gravure screen, but explicitly states that such cylinders are also suitable for the printing of paper.

Nearly twenty years later this article was cited as the most important evidence in a nullity suit before the highest patent court in Germany, leading to the revocation of many later patents by other people. The publication of this article came at the time of the closest collaboration between Fawcett and Klic and one must assume that Klic, who was a member of the Viennese Photographic Society publishing the periodical in which Brandweiner's article appeared, still received its publications. The article was published more than three years before the foundation of the Rembrandt Company.

It is also impossible to establish when the Autotype Company Limited in London started to make pigment paper specially for etching. In 1892 a special brownish-red coloured pigment paper was marketed for the heliogravure process. The company preserves a laboratory notebook,[38] which shows that up to 1891 etching paper was made using the standard 'brown' pigment, but that beginning in March 1892 a special etching paper was manufactured using burnt sienna as pigment, which still today is sometimes used for the production of gravure pigment paper. The notes of the Autotype Company show that this paper was specially manufactured for the firm's German agent Romain Talbot in Berlin, for delivery to a customer in Vienna.

In 1932 R. Storey, the managing director of the Rembrandt Company, stated[39] that the first commercial Rembrandt prints were marketed in 1894, a year before the foundation of the Rembrandt Company. Early in 1895 heliogravures began to be offered in London art shops at surprisingly low prices. These prints can be recognized as Rembrandt prints when they are inspected with a magnifying glass. These *Value for Money Prints* caused great excitement not only in the print trade, but also within the ranks of photographers, process workers and printers, and were widely discussed.

At a meeting of the process group of the Royal Photographic Society in London in 1897, questions were asked concerning gravure printing by machinery.[40] Were Rembrandt prints really printed from intaglio plates? F. E. Ives[41] answered that the works manager of the Rembrandt Company had assured him that the prints were made from intaglio plates, that the presses produced 700 prints per hour, etc. It is noticeable that Ives reported his informant as speaking of plates; as we know today the prints were produced from cylinders. This was a conscious policy of the Rembrandt Company, who for more than twenty years always referred to the printing formes as plates, a habit which Klic strictly adhered to till his death in 1926. Rembrandt prints were embossed with a plate mark to maintain the impression that they were genuine heliogravures printed on a starwheel press.

During the next meeting of the same group of the Royal Photographic Society the theme was discussed again, surrounded by an exhibition of exceptionally beautiful Rembrandt prints. It was stated that machine-printed intaglio did not present any real problems, as long as no differential wiping was required. Several processes were available for the preparation of the plates:

1. Screen negatives were made with conventional halftone screens. They were printed down on to pigment paper and transferred on to a copper plate dusted with bitumen powder.

2. The pigment paper was screened in a printing frame prior to the exposure under the continuous tone diapositive.

Furthermore, it was mentioned that some of the prints exhibited were printed from copper cylinders in the same way as calico is printed. In this case the wiping would be effected by a steel straight edge.

In the same year 1897 a book appeared by Thomas Huson on *Photoaquatint & Photogravure* (Fig.19).[42] Two very beautiful plates are bound in, one a real dust grain heliogravure and the second a Rembrandt print called a 'Machine Printed Photogravure' (Fig.20). The book contains a detailed description of the dust grain heliogravure process and a long chapter 'Treatise on Machine Printed Photogravure', with a detailed description and diagrams of the Rembrandt presses (Fig.21). The description is unusually detailed and

extensive. The ink duct is described and sketched using a wooden duct roller driven from the printing cylinder. Even the doctor angle is given as 35°. Doctor pressure is applied by a spiral spring arrangement. Doctor movement and web lead are described in detail and an instruction for sharpening the doctor blades is followed by a minute description of the printing procedure.

If one looks back today on the developments of the time and sees the number of publications and detailed descriptions which were accessible to all seriously interested, it is unbelievable that in the following ten or twenty years so many claims for the priority of the invention of gravure could have been made in good faith; not only made but also maintained for many years and hotly defended when disputed by people who knew better.

Furthermore, it is surprising that by 1897 Klic had returned to Vienna from Lancaster and officially retired. After the turn of the century, Storey Brothers made him a sleeping partner in the Rembrandt Company. This was probably done to prevent the active artist from selling the carefully guarded secret to other firms. Active indeed was Klic. He was sought after as a portrait painter and experimented not only with printing, but also in lino manufacture, electro-deposition and other allied industries.

No patents exist in the field of gravure, either by Fawcett or by Klic, nor can patents in this field be found under the name Rembrandt or Storey Brothers. Albert[36] states in his Klic biography that Klic patented several of his

HUSON ON
PHOTO-AQUATINT
& PHOTOGRAVURE

A PRACTICAL TREATISE
WITH ILLUSTRATIONS AND A PHOTO-AQUATINT PLATE
BY
THOS. HUSON, R.I., R.E.

To which is appended
A TREATISE
ON
Machine Printed Photogravure
Chiefly Compiled from a number of Original
Articles Contributed to *The Process Photogram* during 1896-9
BY
A. VILLAIN AND J. WILLIAM SMITH

LONDON
PUBLISHED FOR "THE PHOTOGRAM, LD."
BY
DAWBARN & WARD, LD., 6 FARRINGDON AVENUE, E.C.
GERMAN EDITION: KLIMSCH & CO., FRANKFORT-ON-MAIN.

19 (above). Title page of the first book describing machine printed photogravure of 1897. Collection OML.

20 (right). Rembrandt print from Huson's book. Collection OML.

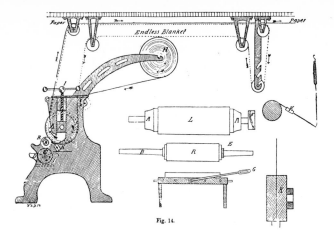

21. Gravure printing press and details from Huson's book.

Fig. 14.

developments for lino manufacture, but that he was unable to trace any such patents. It is very probable that Albert neglected to look into the British patents and applications, because a number of Klic and Klietsch patents are on file. Nevertheless the following patents throw an interesting sidelight on the Klic story, if the dates of the patents are compared with the happenings in Lancaster.

The British patent No. 18937 of 1895 applied for on 9 October 1895 and granted on 7 May 1896 is called: Improvements in or relating to the Manufacture of Linoleum, Kamptulicon and other floor coverings, claiming the cementing together of a number of sheets of prepared material of different colours so as to form blocks or cubes, then taking slices of the ends of these blocks and cementing them together into a block that they show in cross section the pattern required and finally slicing off cross sectional sheets, which may be used directly as floor coverings . . .

There is another patent No. 26281–1896 of 2 January 1897, which was applied for on 20 November 1896, dealing with Improvements in or relating to the Manufacture of Metal Sheets or Strips by Electro Deposition, claiming improvements whereby the process of deposition is continuous and sheets are produced of any required length . . .

Two further patents exist covering details of lino manufacture, No. 16067–1900 and No. 16069–1900, both applied for on 10 September 1900 and granted on 15 June 1901.

A number of patent applications have been found of which nothing more than the number, application date and title are on the books. They are No. 14055, K. Klic, Linoleum of 1895; No. 14107, K. Klic, Tyres of 25 June

33

1896; No.14108, Wheels of 30 June 1898; No.14411, K. Klic, Fixing of hammer heads applied for on 20 November 1896; No.25651, K. Klietsch, Linoleum of 24 November 1897.

It is very interesting to find that all patents in 1895 and 1896 are applied for under his Czech name spelled 'Klic' and that he indicates that he is of Meadowside, Lancaster, but for the 1897 patent application he used the German spelling 'Klietsch'. However, the patents of 1900 revert to the Czech spelling. In these last three patents he describes himself as artist of Vienna XIII, Auhilfstrasse 18. The first linoleum patent was in collaboration with Samuel Fawcett; the investigations leading to these developments must have been made under the auspices of Messrs Storey.

Derek Fawcett, the grandson of Samuel Fawcett, owns a partnership contract between Klic and Fawcett, which is in the form of a letter from Klic to Fawcett bearing the signature of Frank Storey as witness (Fig.22). The letter reads:

'Meadowside Lancaster, 28th October 1895

Dear Mr. Fawcett,

Before I leave for Paris I wish to place on record what I have already verbally promised to you, in relation to our invention for inlaid linoleum. I now repeat such promise, namely that I will give to you Twenty-five percent of the nett profits (after deducting all expenses & outgoings whatever) which I may make by way of royalties or purchase money for both British and Foreign patents relating to such invention.

'It must be understood however that the control and management of the invention and patents & all negotiations in regard thereto are to be left in my hands entirely, and generally the method of dealing therewith must be left to my discretion, and furthermore that the patents are to remain in my name as sole owner of the same.

Yours faithfully,
Karl Klic

Witnesses: Fredk Bannister, Solr Morecambe; Frank Storey, Lancaster.

To Mr. Samuel Fawcett, Lancaster.'

22. Letter from Karel Klic to Samuel Fawcett confirming a partnership arrangement in a linoleum patent. Collection OML. Presented by Mr W. F. D. Fawcett, Lancaster.

Derek Fawcett reported that for many years his grandfather had a yearly income of about £400 out of this contract.

About the turn of the century the Rembrandt Intaglio Printing Company Limited produced industrial gravure prints commercially, under the technical direction of Samuel Fawcett. Klic, who by this time had retired to Vienna, acted as technical adviser and travelled frequently to Lancaster. Very rapidly the Rembrandt Company developed into a sizable firm. A photograph taken in 1905 of the Rembrandt staff (Fig.23) shows that over seventy persons were already employed. A few of the men in this photograph were still alive in 1957 and they not only identified nearly every man in this photo and his position, but they all stated that at the time the photo was taken over eighty people were employed. The successful collaboration of Fawcett and Klic made the industrial use of photogravure commercially successful for the first time. It is, however, true to say that neither of the two brilliant technicians is the inventor of any of the many technical details, which in combination are called gravure. It must not be forgotten that the great merit of these two men was that they succeeded in combining the many processes of details into the gravure procedure as we still operate it today. It can be clearly seen that no invention in the patentable sense existed, because none of the parties involved, neither the firm of Storey Brothers, nor Klic nor Fawcett, ever tried to patent anything connected with gravure. In other fields none of them was shy to apply for patents. Klic, as we have seen, took patents out on other subjects and so did

23. Group photo of the staff of the Rembrandt Intaglio Printing Company, Lancaster, taken in 1905.
Photo owned by Ernest Hampton, Watford.

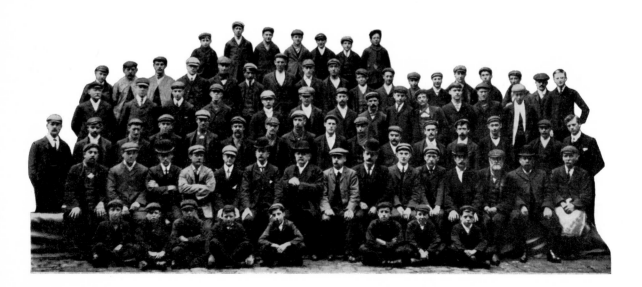

Fawcett in the field of photography, and Storey Brothers for developments in the manufacture of American cloth. It follows that Storey Brothers, as well as Klic who had really had experience with secret processes from the time he invented and worked in heliogravure, would at least have tried to get patent protection if they had seen hope of success. As they realized the impossibility of such legal protection, they were forced to protect themselves by surrounding the method with great secrecy.

The secrecy was rigidly maintained, as some amusing reminiscences testify. For example, when the bichromate solution for the sensitizing of the carbon tissue was required, Klic or Fawcett issued a stone to a labourer for weighing a quantity of bichromate crystals, which were then dissolved in a bucket of water. Afterwards the stone had to be returned, to make sure that the actual weight required could not be discovered.

All working steps were strictly separated in different rooms, and the workmen were not allowed to enter any of the rooms except the one in which they worked. We know today that Rembrandt prints were all printed on reel-fed presses using pre-dampened paper, but each print was carefully plate marked one by one after trimming. All employees of the Rembrandt Company always spoke of the printing formes as plates and never as cylinders, and the few men still surviving in the late 'fifties, when the author spoke to them, had by then not lost this habit.

It really is difficult to understand how it was possible for the Rembrandt Intaglio Printing Company Limited to maintain the gravure monopoly successfully for so many years, and how more than ten years went by before

24 (below). Dr Eduard Mertens, 1860–1919. Photo owned by Dr Mertens' daughter, Frau A. Tetgens, Kirchzarten.

25 (below, right). Ernst Rolffs, 1859–1939. Photographed on his 75th birthday. Gravur Archive Koch Siegburg.

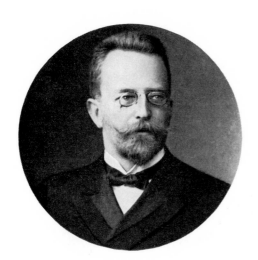

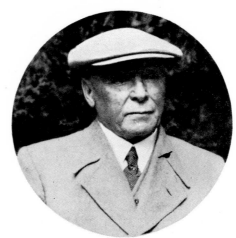

26. Title-page from *Penrose's Pictorial Annual*, Vol. XI, 1905–6. Mezzotinto gravure by F. Bruckmann, Munich. Collection OML.

VERLAGSANSTALT BRUCKMANN, MÜNCHEN

Mezzotinto Gravure
Power-press printed Copper Etching

the first competitor had progressed sufficiently to be able to market similar products.

At a time when the Rembrandt Company produced and sold large quantities of gravure prints, two men in Germany started independently to experiment along similar lines. Dr Eduard Mertens[30] (Fig.24) and Ernst Rolffs[43] (Fig.25) took out their first patents before the turn of the century. But not before 1907 could these two, of whom later we will have much more to say, commence any kind of practical production, and that more than three years after another German firm, F. Bruckmann in Munich, had begun to market screen gravure prints in 1904. Bruckmann called their gravure prints 'Mezzotinto Gravure'. A 'Mezzotinto Gravure' print which can be dated with certainty appeared as frontispiece in *Penrose's Pictorial Annual*, Vol.XI, 1905–6 (Fig.26).

The Austrian Theodor Reich,[44] who worked for many years in England, is responsible for this second gravure printing venture at Bruckmann. Reich worked from 1897 to 1903 as works manager of the Art Photogravure Company in Willesden, London. This firm was the successor to an earlier art printer, L. Collardon. Albert reports that Klic and Reich, when later they were close friends in Vienna, always denied having had any contact whatsoever as long as they were in England. But Captain Louis Collardon, who owned the firm, was a friend of Klic before Klic went to Lancaster and the Collardon firm produced cylinders for textile printing which were seen by Klic. One must therefore at least surmise a contact between Klic and Reich, which possibly was unrealized by either of them. It is not clear when Reich first started to search for a method to imitate or copy the Rembrandt prints. Reich's collaborator, Hermann Horn,[45] reports many years later that Reich had already started to think about it in 1894, even before the Rembrandt Company was incorporated, but says

27. John Wood, 1851–1936. Photo in the reception office of Messrs John Wood, Engineers, Ltd, Ramsbottom.

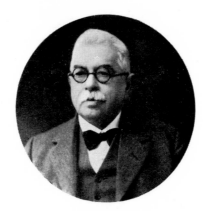

also in the same report that Reich's attention was first drawn to Rembrandt prints when they appeared as illustrations in the art periodical *The Studio*. A search of *The Studio* files revealed that the first Rembrandt prints did not appear in *The Studio* until the volume of 1900. It is also more than probable that Reich started his re-invention only after 1900. The fact is that Reich got in touch in 1902 with John Wood,[46] of Ramsbottom (Fig.27), who was a manufacturer of textile printing presses in competition with Joseph Foster, who had supplied the textile presses for Storey Brothers. Messrs John Wood, who still built gravure presses up to a few years ago, confirm that they built three small gravure reel-fed presses for Reich in the years 1903–4. Reich took the first of

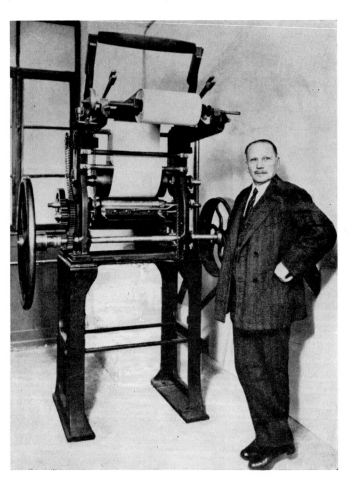

28. Theodor Reich with one of the first reel-fed gravure presses built to print on paper. Collection OML.

these presses to Bruckmann in Munich early in 1904, making Bruckmann the second photogravure printer in the world (Fig.28). The second press built for Reich was taken to Philadelphia in the States by Hermann Horn and Harry Lythgoe, and started production in the American Photogravure Company by the end of 1904.[47]

In 1897 Dr Eduard Mertens founded the Graphische Gesellschaft in Berlin to produce printing rollers for wallpaper and textile printing. He installed a small gravure press (Fig.29) in 1902 in his workshops, which was built by the Société Alsacienne de Constructions Mécaniques in Mulhouse in Alsace, which at that time was in Germany. Mertens' first photogravure print on paper was a picture of the German Kaiser which was printed by the Dessauer Tapeten-fabrik (a wallpaper factory in Dessau, Germany) in 1902. Mertens' investigations and experiments became a world-wide sensation, when the *Freiburger Zeitung* came out with a supplement for Easter 1910 produced on a hybrid letterpress gravure machine.

29. Gravure press, supplied to Graphische Gesellschaft, Berlin, 1902. Photo in the Archives of SACM, Mulhouse.

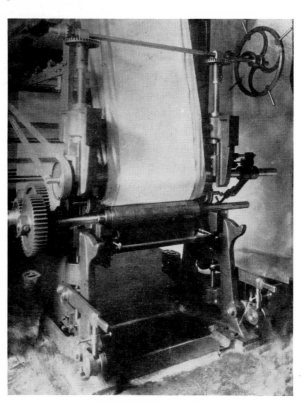

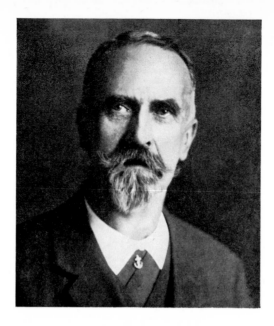

30. Oskar Pustet, 1857–1928. Photo owned by Professor Karl Pechaczek, Vienna.

Ernst Rolffs worked on many problems in his father's textile mill in Siegburg. His first patent was taken out in 1897[48] under the name of his patent agent Dr Maemecke, but his first commercial prints on paper did not appear till 1906, after he had founded the Deutsche Photogravur AG in Siegburg.

The attraction and beauty of the Rembrandt prints also induced other workers in the field of the graphic arts to try to discover their secrets. One of the restless searchers in the field was Alfred Harold Lockington, who before 1900 for a time collaborated with E. Sanger Sheppard, well known as the inventor of one of the first three-colour single shot cameras. In 1899 Sanger Sheppard published an article in *Anthony's Photographic Bulletin*, the New York photographic magazine, describing the production of a doctor-bearing crossline grid on gravure printing formes, by means of a line screen which was twice printed down on to a light-sensitive surface, being turned by 90° between the exposures. Lockington had success in producing gravure prints after he had made contact with John Wood in 1908, and he was able to begin marketing Alezzogravures in 1909 from the firm of John Allen & Co., London.[49]

One other of the interested printing or process workers was Oskar Pustet,[50] who was concerned with Klic's dust grain heliogravure process in the 'eighties of the last century, during his employment at Messrs Loewy in Vienna. Pustet was working later in London at the Swan Electric Engraving Company, which

was founded by Wilson Swan in the sixties, where he met Ives and Lockington in 1893. Early this century Pustet (Fig.30) returned to Loewy, but did not succeed with gravure till Reich joined him in Vienna after completing the introduction of gravure at Bruckmann. The gravure prints by Loewy soon became known under the trade name 'Intagliodruck'.

The Rembrandt Intaglio Printing Company in Lancaster

The fact that a discovery or invention, solving a technological problem more or less finally, is often made by different workers almost simultaneously is one which is frequently met with in the history of technology. This fact is considered surprising and often untrue; however, Professor Robert K. Merton, of Columbia University, says in his article 'The role of genius in scientific advance'[51] that multiple discoveries are the norm, and that a solitary solution is unusual and surprising. We have seen from the description in the previous chapter that gravure, at least as it was executed at the Rembrandt Intaglio Printing Company in Lancaster, was not the invention of a single man, but the result of a close collaboration between Karl Klic and Samuel Fawcett. It will become obvious from the following descriptions of developments, that the strict secrecy maintained by the Rembrandt Intaglio Printing Company required a re-invention of the process. According to Professor Merton, this is the normal situation for such a development. We will see that gravure as we know it today was invented up to 1910 by quite a number of workers. To understand the background for this situation and for the rather multifarious and difficult history of gravure during the first twenty years of this century, one has to go back in detail into the developments of this technique in Lancaster. Karl Klic, who suggested the formation of the Rembrandt Company to Storey Brothers in 1895, had already retired in 1897 from the day-to-day production and settled in Vienna secure in the circumstances of remuneration based on the turnover of the new firm. He did not remain idle, but was actively engaged as we have said in many other areas, such as lino production; however, he had relinquished the right to occupy himself with any problems connected with gravure printing on paper.[36]

The art reproductions, which were produced by the Rembrandt Company in reel-fed photogravure and which were carefully fitted with a plate mark, were offered in art shops at prices with which real heliogravures could not compete. The large output of the Rembrandt Company aroused the curiosity of printers and art dealers. The influence of Rembrandt prints was not confined

to England, because the Company made these cheap art reproductions well known in other countries by an extensive network of active agents in Europe, as well as in America.

A very interesting insight into the production method and the ardent efforts to safeguard the secrecy of the process can be gained from a description given by Ernest Hampton, in a letter to the author of 1958 a few days after he retired from active working with Sun Printers Limited, of Watford. (This company had acquired the Rembrandt Company early in the thirties.) Ernest Hampton can be found in the picture on page 36 showing the staff of the Rembrandt Company, taken in 1906. Ernest Hampton, a boy who had just joined the firm, is seated at the feet of Karl Klic.

Hampton writes as follows:

'During the last few years, I have read several accounts of the early days of photogravure and of the still mysterious beginnings at the Rembrandt Intaglio Printing Co. Ltd. in Lancaster. As one of the few survivors of the early times of Rembrandt, and with a memory still fresh of Mr. Karl Klic or Klietsch and Mr. Samuel Fawcett, who are called the fathers of photogravure, maybe some of the facts as I know them from my own experience may be valuable historical evidence.

'It seems remarkable to me that all the mentioned accounts have been written by people who had never any connection with the Rembrandt Company, nor any personal acquaintance with either Mr. Klic or Mr. Fawcett. I joined Rembrandt as a messenger boy in 1906 and have been with the Rembrandt Company and its successors nearly all my working life till my retirement a few weeks ago.

'Speaking of the dawn of photogravure, the name of Mr. Karl Klic is in every mind. But Mr. Klic was not working alone and all his work in connection with the advent of photogravure was done under the wings of Messrs. Storey Brothers, sail clothmakers of Lancaster. When and why Mr. Klic joined Storeys, I do not know, but when he arrived early in the nineties of last century, Mr. Samuel Fawcett was there, trying to simplify making textile printing cylinders by the applications of photography. Mr. Klic, who had 15 years earlier invented and perfected the beautiful dust grain photogravure process, suggested early in his collaboration at Lancaster that rotary printing on paper from intaglio cylinders would be possible and be an attractive business. Klic and Fawcett's close collaboration for this purpose was soon successful and the Rembrandt Intaglio Printing Company Ltd. was founded by the Storey Brothers in 1895. But at that time neither Klic nor Fawcett were more than technical executives. They became directors only years later. Mr. Klic's position in the early times was not clearly defined and all I know is that he left Lancaster

already in 1897, to settle permanently in Vienna. He remained, however, in close touch with Rembrandt and came back to Lancaster in 1906 just when I started to work there.

'By that time Mr. Klic was already a life director of the Rembrandt Company. Mr. Samuel Fawcett and Mr. Klic were close friends and all the early experiments were made jointly by them. But the running of the firm from 1897 on was entirely in the hands of Mr. Fawcett and he was the process manager. His son William Fawcett, a close friend and pupil of the late Mr. R. B. Fishenden at Manchester School of Technology, followed him in this place, remaining in Lancaster with the Storey firm when Rembrandt moved to London. Samuel Fawcett's grandson, Mr. Derek Fawcett, is to this day process manager of the gravure department of Storeys of Lancaster, but that is another story.

'When I came to Rembrandts, the works were at Queens Mill approximately a quarter of a mile from White Cross Mills, the headquarters of the Storey firm. The veil of secrecy which surrounded every detail of the work at Rembrandt is very well known and prevailed even inside the firm. When I joined, Rembrandt's staff consisted of between 70 and 80 people. A staff group photograph taken at the occasion of Mr. Klic's visit to Lancaster in 1906 shows me as a young boy sitting at the feet of the great man and, looking over the faces, I know that out of the total less than a handful were men who knew the details of the process. All others were considered unskilled labourers and paid as such, who were never told any details of the procedure.

'The etching of cylinders was entrusted to Sam Thompson and only he and Mr. Fawcett shared the secret. However, how effective the secrecy inside the firm was is doubtful and when one day Sam as well as Mr. Fawcett were absent, great consternation was caused by the fact that one of the etching room labourers managed to etch a perfectly good cylinder.

'Rembrandt was quite a small concern on present day standards and they were only little interested in commercial work and not at all in the production of periodicals, which form the bulk of photogravure today. Their field was the reproduction of old masters and only slowly and reluctantly did they progress into the field of auction catalogue illustrations, cigarette cards and picture postcards, etc.

'The photographic studio was at White Cross Mills, away from the Rembrandt works. William Thompson, a brother of the etcher, was the operator and he together with one labourer had 3 cameras at their disposal. The largest camera could take plates of 30″ × 40″. I can well remember one of the well known portraits of Mr. Klic being taken in this old fashioned studio. All negative exposures were made to daylight. The negatives were then sent

to Rembrandt at Queens Mill for retouching.

'This was done by female labour under the supervision of Edward Hunter[52] who later went to America. Retouching was a very lengthy business, after which the negatives were returned to the studio for positive making, again by daylight. Spotting and retouching on diapositives at Queens Mill readied them for planning, which was done in the "yellow room". Nobody ever knew why this room was so called, but I suppose it was done to confuse inquisitive minds.

'The "yellow room" was locked and nobody was allowed in except the heads. As a messenger boy I soon earned the privilege to enter and found the place was very quiet. The planner, Jim Talbot, used similar methods as are normal today, except that all positives were on glass. In this "yellow room" the valuable master screen was kept and the carbon tissue exposed. Again daylight was used if at all possible. In an emergency or during extended bad or foggy weather, mercury vapour lamps were used, but this was rather frowned upon and thought unsatisfactory for quality. I remember special jobs waiting for days for the weather to clear, as mercury vapour was not considered efficient for the particular job.

'Similar methods for sensitizing were used as today, but the sheets were dried on polished copper cylinders revolving close to turning boards. Electric fans were never thought of for this purpose.

'Laying by hand to centre lines on the cylinder, stripping the backing paper and developing was done very much as it is today. Methylated spirit for accelerated drying of the resist was used only in cases when a job was very pressing. We had sometime cases when the negatives were received at 9.0 a.m. and when 500 prints with engraved title and plate sunk were on the train south by 6.0 p.m.

'That was production speed which I think very good going, compared even with present day methods. The title engraving was hand work or done on a pantograph machine, often by female labour under the supervision of Mr. Middleton.

'Naturally no proofing press was available and all revision and make-ready was done on the machines. The impression cylinder was covered with a rubber blanket, which was glued on. After making a print on to the blanket, all margin areas were cut away so that only the engraved portion of the cylinder was in contact with the impression roller.

'All Rembrandt printing up to 1910 was reel-fed, the paper being dampened prior to printing and re-reeling. The printed reel was then cut off by hand guillotining and the prints trimmed to size by female labour, who also did the plate marking using a zinc plate on a guttapercha base.

'The speed of the reel-fed presses was slow, 5000 prints being produced was a good average daily output. In 1910 3 sheet-fed machines specially built by Joseph Foster in Preston were installed, which did at times run at 1000 impressions per hour. The first minder of these machines is still in harness, Dick Whiteside, now working at Sun Printers Ltd. in Watford.

'Millions of cigarette cards were printed at Rembrandt prior to the First World War. The biggest headache was printing the reverse side. A special machine was constructed to try to overcome this difficulty. The machine, however, though a very expensive item was never in practical use. The idea was to have a set of cigarette pictures on one half of the cylinder and the type matter on the other half. The paper was to be half the width of the cylinder and was guided through the machine to turner bars some distance away, and returned through the machine for the reverse to be printed and then re-reeled. The normal method was to print the reverse in letterpress at a small local printer in Lancaster, for which purpose Rembrandt bought a Wharfedale machine and and had it installed at this small shop. The Rembrandt factory had five floors and plenty of free storage space, and it is difficult to understand why so much trouble and expense was incurred in this respect.

'The doctor blades used on the presses were less pliable than those in use today. The traverse motion was worked hydraulically. Doctor pressure was adjusted by weights through a lever system and supplemented often by the minder's own weight.

'The inks used were much thicker than modern gravure inks. No xylol or suchlike materials were ever used, turpentine and gum solutions being used for thinning. All inks were made in Lancaster by Joseph Storey & Co. and ink making and grinding was considered an unskilled job to be done by a labourer who worked to a formula supplied by Mr. Fawcett.

'To preserve the secret of the methods used by the Rembrandt Company, in particular to prevent the realisation that the prints were made on a reel-fed press, we never used the word cylinder. We always talked of plates. This became second nature to all Rembrandt employees, so much so that the few friends who still survive from those early days still say plates when we speak of gravure cylinders. A few years later when Rembrandt prints were widely discussed the main question always was how one could print from flat plates on to a continuous web of paper.

'Years later when the Rembrandt Company was moved to Norwood in South London, Mr. L. T. A. Robinson built rotary gravure machines which used copper plates wrapped round a carrier cylinder and these plates were always referred to as cylinders, to preserve the manufacturing secrets. Our "plates" were cylindrical sleeves of different sizes varying between 20″ and 40″

in length with cylinder circumferences from 16″ to 32″. The sleeves were made from iron which were plated with a thick copper layer at the White Cross Mill and then returned to Rembrandt for grinding and polishing. The grinding was done by stone which was held by an operator against the revolving cylinder. After the stoning a very fine emery cloth and fine emery powder was used for an intermediate polish. This again was a hand operation. The final polish was given using a metal polish, which was thinned into a liquid with kerosene. In later years the final polish was made using rotating metal brushes.

'For printing the reel of paper was fitted with a spindle and fixed behind and above the machine. The paper was unrolled and led over a metal cylinder, which slowly rotated in a trough of water. After passing over this damping roller, the paper passed between the "plate" and the impression roller and then over the top of the machine for a distance of perhaps 50 yards to a rewinding contrivance.

'In this primitive way we worked at the Rembrandt in Lancaster till well after the First World War. It is a pure coincidence that the Rembrandt Company moved from Lancaster to West Norwood in the same year as Karl Klic died in Vienna in 1926.

'Let me close with a few words about Mr. Klic. I only knew him on his second visit to Lancaster. Mr. Klic was very well liked by all people with whom he came in contact, and both he and Mr. Fawcett were especially fond of each other. It was always understood, when he returned to Vienna after his second visit to Rembrandt as a Life Director, that he was a comparatively wealthy man and I believe that to be true. But after the war 1914–1919, inflation in Austria made him a comparatively poor man. I remember the Rembrandt Company's distress at his plight and the trouble they took to get a small amount of money to him. Eventually a small amount could be sent to him monthly, I think about £10.

'I remember Mr. Duncan, one of the directors, and the Company's secretary showing me a letter from Mr. Klic and pointing out to me a special item of expense, for the repair of a chimney in Mr. Klic's house. The sum was 100,000 Austrian Kronen. What inflation can do for the thrifty.

'Karl Klic was getting too old a man to come over to England, even if the authorities would have allowed him to come, but Storeys never forgot their old friend. Arrangements were made with Harrods for each fortnight to send him a parcel of provisions, coffee, sugar, butter, bacon, etc., and this was much looked forward to by Mr. Klic. Coal was also sent to him by parcel post. This had to be wrapped in paper and hessian to prevent dust in the post. An expensive way of supplying coal. However anything for the comfort of an old friend.'

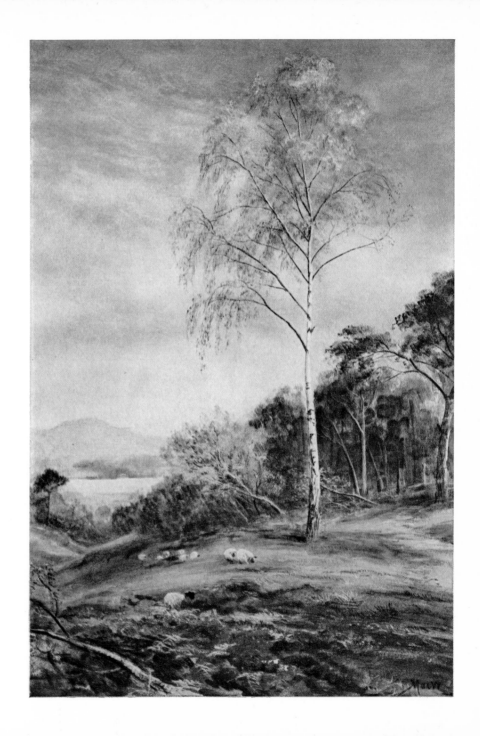

So far Ernest Hampton.

Further valuable addition to this interesting description comes from Alec Middleton, who is seated in the first row, fifth from the right, four places away from Karl Klic (Fig. 23). Middleton retired in 1957 from the Rembrandt Company, which at that time was a subsidiary of Sun Printers in Watford, and lived for several years in Lancaster. Middleton told the author that in 1903 Klic reported from Vienna that he had received an enquiry from a firm in Munich asking for the conditions under which he would instruct them in the use of the Rembrandt process. Middleton says that this enquiry was the reason why Klic was made a director of the Rembrandt Company for life and technical consultant, and that in exchange for this elevation in status he undertook during his lifetime never to give anybody any detailed information about the working procedures in Lancaster. Klic visited Lancaster again, according to Middleton, towards the end of 1904 or early in 1905, to try to produce colour prints by the gravure process, and by the end of 1905 he had succeeded in producing such prints of good quality using only three 'plates'.

In 1906 Rembrandt had started to market the first colour gravure prints. The prints were large size reproductions of paintings.

The first colour print which was produced in a long run was a landscape with a birch tree (Fig. 31). This first print was followed by many other reproductions of paintings by living painters during the next few years. The first colour prints were produced on a wallpaper printing press in the works of Storey Brothers in Lancaster, which was the machine in which the printing units were arranged around a common impression cylinder. Its printing speed was very low to enable the ink to dry in the short interval between the printing units, to avoid a complete smudging of the prints (Fig. 32).

Middleton's description of the required dampening unit for the paper prior to printing differs from Hampton's description. Middleton says that the paper from the reel ran through a water trough and subsequently through a pair of squeeze rollers, which removed any surface water from the sheet.

The description given by these two early gravure workers has to be supplemented in certain points. One understands from Hampton's description of the preparation of the impression cylinders that, after the coating of the stock with the rubber layer, the impression cylinder had to have exactly the same diameter as the forme cylinder, so that after the removing of the rubber from the non-printing areas, the impression always coincided exactly with the print. Looking closely at early Rembrandt prints in the author's collection, one can see that the rubber impression areas are somewhat larger than the actual size of the picture, because in many cases a very slight tone can be seen round the pictures. The question remains of what arrangement had been made on the

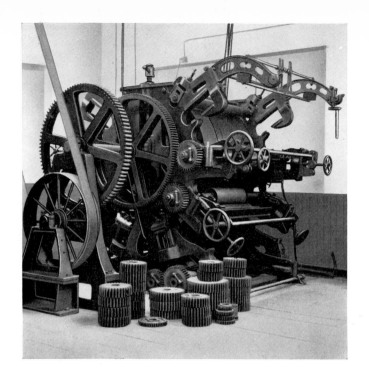

32. Multi-colour gravure press made by Joseph Foster & Sons in Preston, installed 1910 at Rembrandt. Photo taken in 1926 made available by D. W. F. Fawcett. This is a normal textile printing machine.

single colour presses to ensure the continuous feed of the paper, without its being gripped firmly all the time between the impression and forme cylinder. No reliable information on this problem is available. One can assume that at the edges of the webs the impression cylinder contained complete circumferential rings, which were responsible for the transport of the paper.

A confirmation of Middleton's information regarding the enquiry of a Munich firm is given by Albert,[36] who says that the director general, Friedrich Schwartz of Bruckmann in Munich, was in touch with Klic. Thus Klic was made a partner of the Rembrandt Company, the admission to partnership being a recognition of the agreement to keep the secrecy regarding the details of the production of the Rembrandt prints, to which Klic faithfully adhered until his death in 1926.

The Rembrandt Intaglio Printing Company in Lancaster was the first modern gravure plant in the world. The first modern gravure printers were therefore the brothers Sir Thomas Storey, Herbert Lushington Storey and Frank Storey, together with their technical managers, Karl Klic and Samuel Fawcett, the machine-minder George Roberts, the printers Leasdale and Dick Whiteside,

and the three-colour printer Ben Johnson. Further important members of the staff were William Thompson (chief photographer), Edward Hunter (retoucher), Richard Gilchrist (pigment paper handler), Samuel Thompson (etcher) and Arthur Knowles (engraver), who produced the famous prints under the works managership of Jack Sherman. The commercial side was looked after by William Mathews Duncan (secretary of the Company) and the cashier Charles Baxendall. Nevertheless, despite the excellent work of the Rembrandt Company, one cannot say that this firm has real importance in the industrial development of gravure. Rembrandt was a monopolistic firm; the management did everything to prevent the technique, which was developed in their works, from becoming known in the graphic industry or from being used by any other printing houses, and thus from starting to be developed into the industrial process of importance it is today.

The brothers Storey, Klic and Fawcett, with their commercial and technical collaborators and workers, were true to the industrial maxim of the first years of this century. They were only interested in selling the product they produced as long as possible without being involved in any way in the development and progress of the process, not even for their own use. This very narrow-minded business policy soon resulted in technical stagnation and fairly rapid loss of productivity, which is drastically borne out by the fate of the Rembrandt Company. The competition which Rembrandt had to face after the 1914–18 war from the new gravure printing houses, which did not confine themselves as Rembrandt did to the production of art reproductions, and which made liberal use of new developments and methods, forced a move of the Rembrandt Company to London. Here from 1926 onwards, under the direction of L. T. A. Robinson,[53] the Company tried to modernize itself to produce gravure from thin plates, which could be wrapped around carrier cylinders in a similar way to offset plates, to produce colour prints. However, the Company did not achieve an economic working procedure. In 1932 the largest gravure installation in England, Sun Engraving Company at Watford, acquired the interest of Storey Brothers, who had decided to confine themselves to their textile and American cloth production,[54] and Sun Printers transferred the Rembrandt works to Watford. Here the Company was changed under the direction of Sun into a modern sheet-fed gravure printer with the name of Rembrandt Photogravure Ltd, which was incorporated into Sun Printers Ltd in 1961. So after sixty-six years the history of the Rembrandt Intaglio Printing Company, which was built on the work of Karl Klic and Samuel Fawcett, came to an end.

Theodor Reich, Bruckmann in Munich and J. Loewy in Vienna

The Rembrandt Company in Lancaster had hardly any direct influence on the further development of photogravure. However, the superior quality and cheap price of Rembrandt prints, which were increasingly popular around the turn of the century, were the reasons why a number of technicians and inventors became interested in investigating the problems of the mechanical production of heliogravures.

Hermann Horn, about whom more will be said in a later chapter, was the first one to introduce gravure into the United States. He reports[55] that he emigrated to London in 1892, where he was a poorly paid wood-engraver and retoucher. Soon he found employment with the Art Photogravure Company in South Kensington, where the Austrian Theodor Reich was employed as a heliogravure etcher and later rose to the position of works manager. In the following years Horn was a frequent visitor to Reich's home at Willesden. One evening Reich showed him a print in the current number of the magazine *The Studio* which looked very much like heliogravure, even if certain characteristics of heliogravure prints were absent. It was the first Rembrandt print which Horn remembers seeing. Reich was convinced that these heliogravures were produced on a reel-fed printing press, but he could not understand how the bitumen dust grain could be fixed to a cylinder, and he could not explain the meaning of the light crosslines which seemed to overlay the print in the form of a regular network. It is obvious that these discussions must have taken place in 1900 or a little later, because a check of *The Studio* showed that the first Rembrandt print was published by that magazine in 1900.[56]

In Horn's article in *Print and Progress* he reports in detail that on another visit to Reich's well-furnished house a few months later, he saw in the centre of the living room a small reel-fed gravure machine occupying about one square yard of the floor area. On the mantelpiece he saw a few small copper cylinders and some glass diapositives and similar 'ornaments'. Reich demonstrated jubilantly a paper web many yards long, with prints which appeared in every respect identical with the Rembrandt prints.

A search in the archives of the engineering works of John Wood at Ramsbottom near Manchester revealed the following information:[57] John Wood, born in 1851, founded at Ramsbottom in 1881 a small mechanical workshop to which he attached a small foundry. In 1902 a certain Theodor Reich from London visited Ramsbottom to experiment on a small textile printing press made by John Wood with photogravure cylinders he had etched. The first photogravure printing press to be used on paper was built for Reich by Wood in 1903. Reich used this machine in his London flat. The machine was later installed in the works of J. Loewy in Vienna. The machine was designed for 20-inch wide paper and was delivered for £140. In 1904 a two-colour gravure machine[58] was designed by Wood and also a further single-colour press for Messrs Bruckmann in Munich. The next machines for photogravure on paper were built in 1907 also for Bruckmann in Munich, and in 1910 for Bemrose & Son, of Derby, and for Mr Corkett, of whom we will write later. During the period from 1911 to 1914 further photogravure machines were made for J. A. Hughes, the Swan Electric Engraving Company, Allen & Co., John Swain & Sons and Andre and Sleigh, all of London, and also for Vandyck Printers Ltd in Bristol and SADAG in Geneva. Furthermore several machines were built for His Majesty's Stationery Office; some of these presses we will meet again in further discussions.

Messrs Bruckmann KG in Munich issued a publication in 1958 called '100 Years a Bridge to Art' (*Hundert Jahre Brücke zur Kunst*). This booklet states: 'The first photogravure machine was installed at Bruckmann in 1900.'

This information, however, cannot be accepted as correct, but one can conclude from Wood's archives that the information is correct which Horn gave in his article for *Print and Progress*,[45] namely that Reich very soon found a buyer in Germany for his invention and the machine, and that he moved early in January 1904 from London to Munich. Bruckmann started to market 'Mezzotinto Gravure' by the end of 1904.[59] These prints were single-colour, reel-fed rotogravure prints. Hans Vetter, who retired from Bruckmann in 1956 when he had reached the age of 75 after forty-nine years' work with Messrs Bruckmann, says[60] that he started work at Bruckmann in 1910 and that at that time reel-fed gravure production at Bruckmann had already been in use for several years. In a further letter Vetter states: '. . . gravure printed on reel paper and marketed under the name of Mezzotinto was first produced in 1903 or 1904. The prints were printed on a small machine which had a web width of 20″ (Fig.33). As far as I can remember, Herr Hugo Bruckmann went to England about that time and apparently conducted the negotiations and contract during his stay in London. I am unable to say what was the first print produced on this press. Later on this machine and several others were occupied

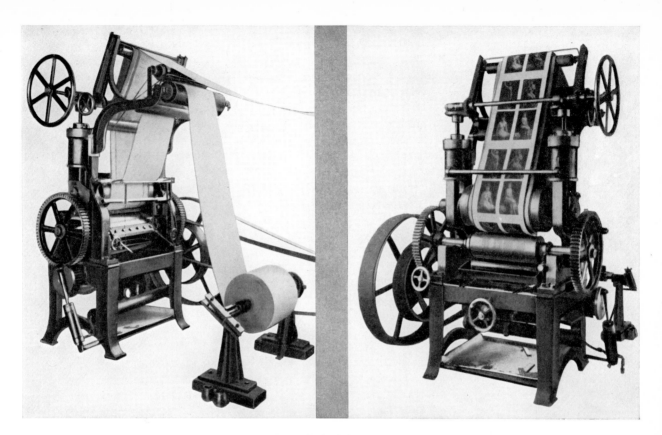

33. Reel-fed gravure machine made by
John Wood in Ramsbottom, installed at
Bruckmann in Munich in 1904. Photo
supplied by F. Bruckmann KG, in Munich.

to capacity and a little later even postage stamps were produced on them. Herr
Theodor Reich was very much concerned with the whole installation and lent
a hand in the actual finish of the installation.'

There is no doubt whatsoever that Bruckmann was the first modern gravure
plant in Germany and the second plant in the world after the Rembrandt
Company. It is well documented that Bruckmann produced commercially
reel-fed gravure prints by the end of 1904, or at the latest very early in 1905.
Already in 1884 Bruckmann had bought from Klic in Vienna[61] the heliogravure
process, and became in this way the first heliogravure printer in the world.

We know already that the managing director of Messrs Bruckmann,
Friedrich Schwartz, had tried in 1903 to buy the secret of the Rembrandt
process from Klic. By his refusal Klic gained his partnership in the Rembrandt
Company at Lancaster. It is, however, a mystery how Bruckmann approached
Reich within a few months after Klic's refusal. We have already mentioned, in

our discussion of the development of the Rembrandt Company, that it is not at all certain whether Reich really invented the photogravure process completely independently of any influence or contact with the work of Klic. It is known that he was working in the Art Photogravure Company whose owner was Captain Collardon, a close friend of Karl Klic for many years. Therefore it is probable that there are some possibly only subconscious connexions.[62] It must be stated, however, that no real contact has so far been proved, and one is justified in claiming for Reich the honour of being a genuine inventor of the gravure process. Before continuing the story of Reich, it is necessary to describe certain details in the development of the Bruckmann company.

With the exception of an entry in the order book of Messrs Wood in Ramsbottom, concerning a second reel-fed gravure machine for Bruckmann to be delivered in 1907, nothing is known of such a second machine, even though Vetter in his letter reports that 'several presses were running to capacity at this time'. We know from Hermann Horn[63] that the first small gravure machine which Reich brought to Bruckmann was sold to the printing press manufacturers MAN in 1913. This press was used in the experimental gravure printing department of the MAN in Augsburg, where Horn was employed till his death. Regarding the postage stamps which Vetter mentions as being printed on the old press, Krahwinkel, the secretary of the Society for Postal History in Bavaria (Gesellschaft zur Erforschung der Postgeschichte in Bayern E.V.)[64] (Fig.34), says: 'Gravure processes are copper engraving, steel engraving, dust grain heliogravure and the Mezzotinto process (screen gravure) . . . New and surprising was the fact that the editions of the King Ludwig postage stamps of March 1914 were produced in Mezzotinto, which is reel-fed rotary gravure. Never before had this printing process been used for the production of postage stamps. They created a sensation . . . The first proof prints of postage stamps were supplied by Messrs Bruckmann in Winter 1912. Responsible for the suggestion to try this new process was Professor Emmerich in Munich, supported by Mr von Frauendorfer, the Bavarian Minister of Commerce, and his under-secretary, Schwarz. The design showed the Prince Regent Luitpold . . . Also Messrs Brend'amour Simhart submitted postage stamp proofs in rotogravure to the Ministry of Post, mentioning in the tender that the printing presses for their production were manufactured in Bavaria (Frankenthal).[65] In the Postal Museum in Nuremberg a gravure cylinder for the Wood machine can still be seen today, etched with the Ludwig stamps, as well as several proofs and experimental prints. The cylinder is 21 inches long and has a circumference of $12\frac{1}{2}$ inches. The etching consists of two postage stamp sheets side by side, each containing 100 stamps of $7\frac{1}{2}$ Pfennig denomination (Fig.35.)

W. D. F. Fawcett, the grandson of the co-founder of the Rembrandt

34. Gravure printed postage stamps.
Top: Trial stamps by Rembrandt.
2nd row: Bavarian stamps printed by
Bruckmann in Munich 1913–14.
3rd row: Rumanian stamps 1922 and 1926
printed by Bruckmann.
4th row: First stamps printed by
Harrison & Sons for Egypt 1923 and by
Vaugirard in Paris for French Morocco.
Collection OML.

Company, who early in the 1960's was the manager of the gravure department (textile and man-made fibre printing) of Messrs Storey in Lancaster, told the author[66] that Rembrandt prepared postage stamp proofs for their London sales manager before 1910, at the time when the postage stamp printing contract for the British postage stamp, held by Waterlow and Sons, came to its end and the postal authorities issued a tender for the renewal of the contract. The London sales manager did not deliver the proofs and also neglected to send in an offer, because he believed that gravure would not be an acceptable printing process for the postage stamps of the United Kingdom. The normal process

35. Original etched cylinder for Bavarian Ludwig stamps for use in a John Wood gravure machine at Bruckmann. Preserved in the Postal Museum in Nuremberg. Photo lent by Gesellschaft zur Erforschung der Postgeschichte in Bayern.

for the production of postage stamps at that time was either steel engraving or letterpress. After renewing the contract with Waterlows, the postal authorities investigated why Rembrandt did not submit a tender, because great things had been expected from the gravure process. The proof shows the head of King Edward VII, which confirms that this happened between 1901 and 1910. Till 1918 the Luitpold postage stamps for the Bavarian postal authorities produced by Bruckmann remained the first and only postage stamps printed by reel-fed gravure. Immediately after the First World War a new edition of postage stamps for Württemberg was produced in Stuttgart. This was the second gravure postage stamp series produced, if one neglects to count an official forgery of the Bavarian Ludwig stamps which were produced at His Majesty's Stationery Office in London on a Wood press during the 1914–18 war for use by spies sent behind the German lines. Only in 1922 and in 1926 were further editions of postage stamps produced by Bruckmann in Munich, for Rumania.

In 1922 Vaugirard in Paris produced postage stamps by gravure for French Morocco and about the same time Harrison & Sons of High Wycombe started experiments which led to the gravure production of Egyptian stamps for the editions of 1923 and 1924. It was planned that these editions should appear in steel engraving; however, before the engravings were finished, Cairo urgently requested proofs which were made by reproducing the original essays in reel-fed gravure. When later the proofs of the engraved plates arrived in Cairo, it was found that the prints from the screen gravure cylinders were more attractive and it was decided to produce the edition in rotogravure. Up till the end of 1930 eighteen countries had produced postage stamps in gravure, and in 1940 the number of countries had already risen to forty-seven.[67]

The installation and beginning of the 'Mezzotinto Gravure' at Bruckmann

kept Reich in Munich only a few months, because by the end of 1904 we find him in Vienna engaged in the production of 'Intaglio Prints' for J. Loewy.

Professor Franz Gesierich, of the State College and Research Station (Staatliche Lehr- und Versuchsanstalt) in Vienna, reports on the beginnings of gravure from his own experiences, for in 1902 he joined the K. & K. Hofkunstanstalt J. Loewy in Vienna.[68] At the time Loewy was equipped to produce letterpress, collotype and heliogravure prints. His process department for mono and colour blocks was world famous. In 1904 after Theodor Reich had joined Loewy the entrance door to the heliogravure department suddenly carried a large sign saying: 'Only authorized personnel may enter this department.' It could not remain a secret for very long that a new printing process was undergoing experiment intended to replace the collotype production, which would permit the mass production of heliogravure-like prints. At the time Oskar Pustet was the manager of the heliogravure department. He and Reich were close friends in London when both were working at the Swan Electric Engraving Company under Frederick J. Ives on the problems of halftone photography. Karl Wittak was employed as etcher, together with Guido von Webern, who was a printer and whom we will find again at the National Cash Register Company in Ohio about 1912. Franz Dunkel specialized soon afterwards in the printing of the colour gravure prints, which Loewy marketed under the trade name 'Intagliochrome'. How seriously Loewy took the secrecy of the work which was going on behind this door can be seen from the fact that all the named employees had to pay a guarantee of 2000 Kronen. Pustet had started to investigate the possibility of screen gravure etching after Reich had sent to him the first of his gravure prints. The first experiments in Vienna were made on plates. Gesierich describes at length how he attempted unsuccessfully the production of a gravure screen by soaking a normal halftone screen in hot turpentine, to divide the two crossed line-screens. He then tried to produce a crossline gravure master screen by printing down the line screen twice, crossed by 90° on to a light-sensitive stripping layer. Finally he succeeded in making a master screen from which the working screens were produced by contact printing. The plates were printed in a modified collotype press and the printing inks were also made on the premises.

Soon afterwards a small reel-fed machine was installed. This is probably the second machine which Reich had used in London and which is illustrated in Fig.28. The first large order to be printed by the new process was a million postcards for Dreher's Brewery. A year later the first three-colour gravure print was produced, a female nude painting by Veith. It is not known if Reich was still employed at Loewy's when this print was produced.[69]

It seems that Reich had no noticeable financial gain either from his work

with Bruckman or with Loewy, because by the end of 1905 he had moved to Berlin to Meisenbach Riffarth & Co., where he developed the 'Heliotint Gravure'. Here we must listen to Wilhelm Gustav Horn,[70] who was working from 1945 to 1954 in the London collotype works of Ganymed Ltd as chief colour retoucher. He has no family connexion with Hermann Horn. Wilhelm G. Horn told the author: 'I was engaged from 1900 to 1923 by Meisenbach Riffarth & Co. in Berlin as photographer and retoucher. In 1905 the photographic department was situated in Friedenau, a suburb of Berlin, but the heliogravure printing department was situated at the headquarters in Hauptstrasse in Berlin-Schöneberg. The print room contained sixty star wheel presses. Reich came to Meisenbach by the end of 1905 to introduce something new. Whoever was not directly concerned with the new development was not allowed to walk through the workrooms of the heliogravure department. The new experiments were personally managed by Herr Riffarth. In the beginning film line screens were used. I was asked to produce diapositives, but it was a heartbreaking job, sometimes they should be contrasty, sometimes soft. After a long time and after I had been sworn to keep strict secrecy regarding everything I saw and heard, I was finally permitted to see what the diapositives were used for, which enabled me to arrive at a standard which could be used. The printing press was a modified lithographic printing machine, which could be used to print very slowly from thick copper plates (approximately $\frac{1}{2}$ inch) using a doctor blade. Four etching solutions were used for etching, which were kept in four separate dishes placed next to each other on a table, and the plates were transferred from dish to dish by a small overhead crane running along the table. The first large job was a series of twelve postcards issued for the opening of the Berlin luxury restaurant 'Rheingold'. They created a great sensation. The negatives for these postcards were made by a well-known photographic studio in Leipziger Strasse. I made the diapositives and also retouched them. The etcher's name was Berger. About 1910 a Kempe-Blecher sheet-fed gravure press was installed in Hauptstrasse for the production of the further gravure prints using printing inks made by Gebrüder Schmidt in Berlin.'

Before 1910 Theodor Reich designed a cylinder grinding and polishing machine, which was also bought and installed at the Rembrandt Company in Lancaster.[71] Later Reich became gravure manager at Messrs Elbemühl in Vienna. Reich was born on 23 September 1861 in Vienna and died in that town on 17 June 1939.

Ernst Rolffs and Eduard Mertens

Without wasting energy on the manifold organizational and commercial complications of patents, contacts, and so on, Fawcett and Klic, as well as Reich, confined themselves to the developing of a usable printing process and to the employment of this in a most advantageous way. The Rembrandt Company, who let the inventors take part in the financial success of their invention, worked as a monopolistic user of a jealously guarded secret process. Reich worked by selling his practical experience and detailed knowledge, which were in no way protected and which gave no monopoly whatsoever to the printing houses making use of his advice. Klic, by the fairness of his friends and English partners, reached a reasonably comfortable state, but his labour only resulted in a very limited number of people being gainfully employed, who were the direct employees of the Rembrandt Company. On the other hand, Reich took no part in the economic success of the products which were made by using his invention. He sold his customers a new means of production and was forced to work very hard all his life. He was reasonably well paid, but lived a life far removed from bourgeois comfort. Klic, as well as his friend and collaborator Fawcett, and also Reich were craftsmen and not industrialists. Reich made it possible that gravure as a profitable printing method was introduced into several printing houses. However, the two men who, with their collaborators, can claim the honour of having developed gravure into an important industrial process are Dr Eduard Mertens and Ernst Rolffs (Figs.36 and 37). They advertised widely and interested a wide circle of printers by demonstrating the processes they had invented and perfected into practical systems which could be used on an industrial scale. They were the first to achieve success by using systematic personnel training on behalf of their customers. Furthermore they were responsible for having interested printing-press manufacturers in the design and construction of new machines required for their process. The influence which these two men had on the development of gravure during the first twenty years of this century is so closely connected that it is necessary to treat them together in one chapter.

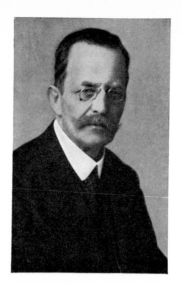

36. Dr Eduard Mertens, 1860–1918. Photo taken in 1918, owned by Mrs A. Tetgens, Kirchzarten.

37. Ernst Rolffs, 1859–1939. Bronze head in the Heimatmuseum in Siegburg.

In 1891 Ernst Rolffs became a junior partner in his father's cotton printing works, Rolffs & Co. in Siegburg. We have heard that Fawcett aimed at simplifying the tedious method of the production of textile printing rollers by the use of photographic methods. Rolffs reports[72] that for similar reasons he worked for a while in the photographic training establishment of Messrs Klimsch & Co. in Frankfurt, to familiarize himself with modern methods of process photography and blockmaking. It looks as if the intensive preoccupation of the junior partner with the problems of the production of textile printing rollers by modern photographic means was frowned upon by his partners.[73] In a letter dated 9 December 1898, Rolffs' father advised his son not to proceed with his experiments in the photo-mechanical production of textile cylinders, because this was of no interest to the cotton printing organization. As a consequence, Rolffs resigned his partnership early in 1900 and concentrated all his energies on his photo-mechanical investigations. He set up his workrooms adjacent to his father's factory and no doubt received help with his experiments.

On 13 June 1899 Rolffs applied for a patent using the name of his patent agent Julius Maemecke, who was employed in the Berlin Patent Attorney's Office, A. Kühn and R. Dreiser. His patent is called 'Screened Gravure Roller' and has the following claims:

(1) Photographically produced engraving on printing cylinders for textile printing specified by the picture consisting of dots or lines in intaglio of different depths and breadths, which combine to a continuous line or

crossline pattern bordering the incisions, serving to keep the doctor blade in the plane of the cylinders without endangering the design details.

(2) Method for the production of printable engravings and textile printing rollers using photographic means. In the manner that first a collodium skin negative or diapositive is produced using a normal halftone screen, so that the picture appears as black or transparent dots on the film, situated in a continuous transparent or dark screen mesh. This skin picture being exposed on to a roller which has previously been made light-sensitive using, for example, a chromated fish glue, and subsequent etching of the picture so created in a known manner.

(3) A different method from the process mentioned under (1) using a line screen situated in such a way that the lines are not parallel to the doctor blade.

Very detailed scrutiny was given to the application by the apparently very knowledgeable Controller at the German Patents Office, Regierungsrat Dr Beer. He answered with very relevant objections which led to an interesting addition to the patent claims.[74] He also referred the inventor to Brandweiner's publication of 1892[75] in which Brandweiner says: 'I produce the engravings by . . . assuring during the exposure of the positives that the negative is in contact with a screen which serves to dissolve the areas into a line system . . . without which continuous tones cannot be printed . . . It is therefore essential that these tones are divided into dots and dashes for which the most suitable means is the halftone process.'

The Patent Office official realized much better than the inventor himself the quintessence of Rolffs' idea, and says that the only really new thought in the invention is the use of a crossline screen.

Thereupon Rolffs altered the patent description and also the claims. On 12 December 1902 he was granted the Deutsche Reichs Patent No.129679, which during the following ten years was frequently fought over. On 26 November 1910 this patent, after a long battle with objectors, was finally revoked. The claims which now become valid say:

(1) Gravure cylinder with a crossline screen raised over the total of the etched picture area.

(2) Method for the production of such gravure cylinders in which a diapositive is used for printing down on to the cylinder in a well-known manner which contains a transparent crossline net.

For the history of gravure it is important to note that this patent, as well as the original application and the long-winded correspondence between the inventor and the Patent Office, which lasted more than three years,[76] always mentions gravure cylinders for textile printing only. It appears that Rolffs had never thought of any other application of his invention. On the other hand, in

Brandweiner's article which appeared in 1892 special mention is made: 'Because fabrics accept much more ink, it is necessary that the engraving is made considerably deeper than similar engravings would need for printing on paper.' Somewhat later in the same article it is specifically stated: 'Cylinders can also be used to print on paper . . . the printing took place on reel-fed paper and the results were very good indeed.'

Rolffs claimed very much later that in 1900 he had already made experiments to use his invention in the production of newspapers, and that at that time he had had negotiations with the technical director Anselm Hartog of the Berlin newspaper publishing house, Rudolf Mosse.[77] The first time that Rolffs mentions printing on paper is in a letter which he wrote to the Graphische Gesellschaft in Berlin on 23 October 1901.[78]

In 1903 Rolffs read a paper to the Fifth International Congress of Chemistry, held in the Reichstag Building in Berlin. He showed three-colour prints on textiles and said in his paper 'The Rolffs three-colour printing on textiles' . . . 'Apparently the printing on paper is much advanced regarding the production of the designs, compared with textile printing. Therefore I decided to study first of all printing on paper . . . Halftone printing as it is used for the printing of illustrations on paper is useless for the decoration of textiles, because in textile printing the ink has to come out of the recesses of the printing forme, whereas printing on paper prints from the surface . . . My gravure process is based on the intaglio principle on which all other methods used in cotton printing are based . . . My process has been developed for textile printing, but recently it has been thought interesting also for printing on paper, wallpapers and illustrations. The largest engraving house for the production of rollers for wallpaper printing has now started to use my process. The next step will be its application to illustration printing, because it is clear that the same pictures and effects which up till now have been produced from plates, can also be produced using rollers . . .' Rolffs does not mention the name of the engraving house to which he refers, but this is the Graphische Gesellschaft in Berlin owned by Dr Mertens.

In 1889 Dr Eduard Mertens started a printing and publishing house for the production of art books and folders with reproductions of paintings, as they were very popular at the time. The methods used were letterpress and collotype. Somewhat later he started experimenting with the photo-mechanical production of printing rollers for textile and wallpaper printing. This led to the foundation of the Graphische Gesellschaft in Berlin, Dr E. Mertens & Co., in 1897. This firm started as a trade house for the delivery of printing rollers for wallpaper production. The first patent taken out by Dr Mertens[79] describes a whirler in which the roller is coated. This method of applying a light-sensitive coating to

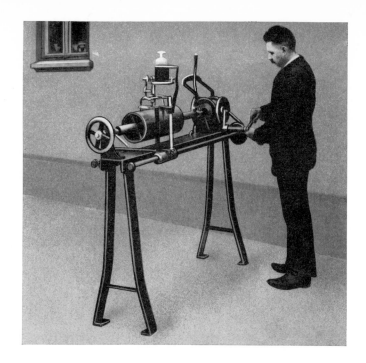

38. Cylinder coating machine according to Rolffs' patent No. 114924 used in the courtyard of Messrs Carl Aller, Valby-Copenhagen in 1908. Photo supplied by Claes Aller.

a cylinder proved less good than a method which somewhat earlier had been patented by Rolffs, in which he applied a light-sensitive solution in the form of a thin spiral to the cylinder using a primitive lathe (Fig. 38).[80]

The first contact between Mertens and Rolffs appears to have taken place in the autumn of 1901. During their discussion it transpired that the Graphische Gesellschaft had also supplied rollers for textile printing. In Rolffs' copybook kept in the Heimatmuseum in Siegburg, a letter to Dr Mertens can be found accompanying Rolffs' despatch of one of his first handkerchiefs printed by his photogravure process. In a further letter dated 23 December 1901 addressed to the Graphische Gesellschaft Rolffs says: 'I have received the printed cloth you sent me and have pleasure to say that I would consider a collaboration with you regarding the exploitation of my patents . . .'

Rolffs owned the patent 'Screened Gravure Roller' which has already been mentioned and which for many years was the reason for serious disputes between the interested parties. This patent appeared to give Rolffs a monopoly of using screened gravure cylinders. His further patents only deal with the coating of cylinders with a light-sensitive layer and the production of pictures on such rolls. The last patent taken out by Rolffs dates from the year 1902 and

refers to printing inks produced with soluble dyes for the colour printing of textiles. Only one other patent was taken out by Rolffs in 1914. The correspondence between Rolffs and his patent agents[81] shows clearly that he was also claiming the invention of putting a dampened collodium skin picture on to the light-sensitive cylinder, but the Patent Office told him in no unmistakable terms that this was a well-known process for blockmaking and that changing from a light-sensitive plate to a light-sensitive cylinder was a step which was obvious to every process worker, and did not represent an invention at all. It appears that the inventive genius left Rolffs very suddenly in 1902, and it is very difficult to say how far Rolffs' patents really were his own inventions. It is suspicious that Rolffs is not mentioned at all in the patent literature after 1902 and that in later years, as we will see in this story, Rolffs tried very frequently in vicious pamphlets and polemic letters to put his 'great inventions' in the foreground, and that these pamphlets in particular are full of obviously incorrect statements. In the Heimatmuseum in Siegburg are kept a number of autobiographical sheets written by Rolffs:

'1900. On 1 January 1900 Herr Ernst Kühne joined the experimental gravure department of Mr Ernst Rolffs. The department was already fully equipped and installed by Ernst Rolffs, so that Herr Kühne could start immediately by using his experience as a process photographer. A little later further assistance was engaged. The experimental gravure department was situated in the rooms of the cotton mill. It must be stressed most emphatically that no employee of the cotton mill was ever employed in the gravure department, not even Dr Nefgen who was in charge of the laboratory of the mill, which was a fair distance away from the gravure department. Dr Nefgen left the employment of the mill in the spring of 1902. Only in 1 April 1903 was Dr Nefgen engaged by

39. Cylinder exposure unit for the Mertens process. The machine serves for coating, exposing and developing the resist. Exposure by means of a mercury vapour lamp. Archives Gerhard Koch, Siegburg.

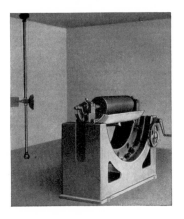

Ernst Rolffs to collaborate on gravure printing. Mr Ernst Kühne remained with the gravure plant till June 1903 . . .'

The tone and the obvious attempt to gild his own achievements and to denigrate the work of his collaborators Kühne and Dr Nefgen are suspicious.

During the year 1900 Dr Martin Schöpff joined the Graphische Gesellschaft.[82] He and Dr Mertens were now working energetically on all problems concerning the production of gravure printing rollers for wallpaper printing. The enormous creative work of these two men in the Graphische Gesellschaft during the next ten years can be clearly seen by a study of their patents. They actively developed the whole area of the production of printing rollers and the use of them.[83] Starting with lighting arrangements for photographic cameras as well as for print-down equipment on to the cylinders (Fig.39), they investigated many possibilities in the production of halftones and other methods of screening for the smoother working of the doctor blade. They were also active in investigating the possibilities of keeping the sides of the cylinders clear of ink. They designed printing presses and took out patents for simultaneous printing of text and pictures on gravure machines, and also for hybrid presses combining letterpress units with gravure units. Their patents covered the various possibilities of transferring pictures by direct printing down on sensitized rollers, as well as indirect methods by mechanical laying of pre-exposed stripping layers. They investigated the necessity for screening fine details and fine type. They also produced chrome colloid covered papers and the combination of type and picture diapositives for planning purposes (Figs.40 and 41).

Therefore it is not impossible that the information is correct that part of the daily *Der Tag* dated 26 April 1904 was produced on a photogravure press simultaneously printing type and pictures,[84] but nothing is known concerning the press on which this experiment took place. From information supplied by the Société Alsacienne de Constructions Mécaniques in Mulhouse, the first single-colour photogravure machine with rewinding unit was supplied to Graphische Gesellschaft in Berlin, Lindenstrasse, on 15 December 1904. One must assume therefore that this page of *Der Tag*, which Professor Eder says he saw, was printed on this machine or on a wallpaper printing press in the plant of one of Dr Mertens' customers. This may have been the Tapetenfabrik Ernst Schütz in Dessau, for which Mertens is said to have etched a portrait of the German Emperor in 1902,[85] or perhaps Messrs Schlumberger & Fils in Mulhouse, who were business associates of Dr Mertens in 1903.

Obviously the Rolffs patent 'Screened Gravure Roller' was seriously hampering Mertens' works. When preliminary negotiations between Mertens and Rolffs had yielded no positive result towards collaboration, Mertens sued

40. Equipment for the Mertens process, 1908. Paperdamping unit made by R. Hoe & Co., London (top). Used for web conditioning. Cylinder etching table for invert halftone etching in use at Broschek in Hamburg in 1912 (below).
Archives Gerhard Koch, Siegburg.

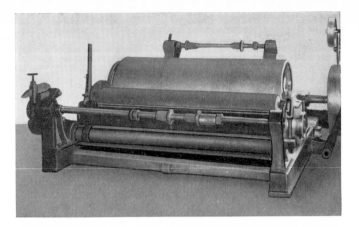

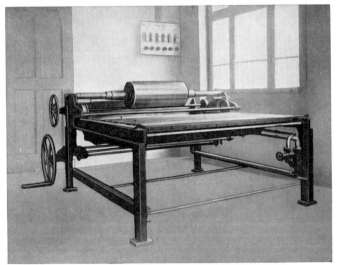

for nullity of the patent. Unfortunately one can no longer find out today which reasons Mertens gave in his application for a nullity declaration of the patent, but obviously the claims must have been quite justified otherwise Rolffs, who was disinclined to collaborate with anybody, would not have been prepared to come to terms with Dr Mertens. They entered into contracts which were dated 11 November 1905 and 19 January 1906,[86] and which gave Mertens the right to the use of all Rolffs' patents in compensation for Mertens' agreement not to proceed with his nullity claim, and arranged that Mertens was entered into the Patent Office files as co-owner of the DRP 129679.

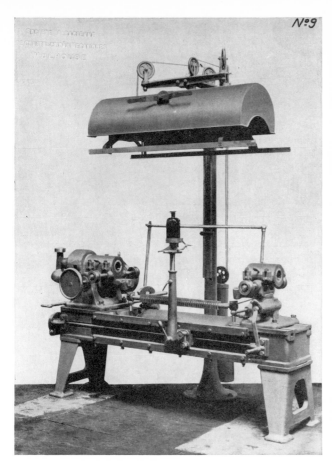

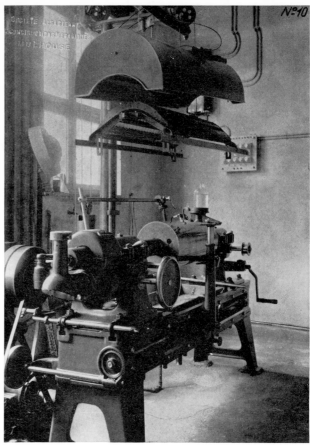

41. Combined cylinder coating and exposing unit for the Mertens process.
Archives of the Société Alsacienne de Constructions Mécaniques, Mulhouse.

A few days later, on 24 February 1906, the two private contracts were supplanted by the foundation of Deutsche Photogravur AG in Siegburg. The company was founded with a capital of DM 1 300 000, of which Mertens was allotted DM 666 000 and Rolffs DM 334 000, which were considered as fully paid up by the bringing in of all patents and experiences of the two founders. The company was founded for the production and sale of graphic products. Board members were Dr Martin Schöpff and Dr August Nefgen (Fig.43). The Supervisory Board prescribed by the German laws for limited companies on shares was composed of Ernst Rolffs, as Chairman, Dr Eduard Mertens, as Deputy Chairman, and Messrs C. Später, Dr Karl Popp, Dr Karl Bleibtreu (Fig.42), General Conrad Wunderlich, manufacturer Albert Schlumberger,

42 (left). Dr Karl Bleibtreu, photographed in Siegburg, 1908.
Archives Gerhard Koch, Siegburg.

43 (right). Dr August Nefgen, photographed in the laboratory of Maschinenfabrik Johannisberg in Geisenheim in 1928.
Archives Gerhard Koch, Siegburg.

farmer Arthur von Osterrath and public notary Uflacker.

It is not at all certain where the first single unit reel-fed rotogravure press, which was installed in a new building by the middle of 1906, originated. This machine may have come from the textile printing works in Siegburg or, looking at the first annual report of the young company, more probably from Berlin. During the course of the year 1906 a three-colour machine was ordered from Mulhouse. This machine was delivered on 19 January 1907. The machine was fitted with a reel stand and re-reeling unit and a festoon drying arrangement supplied by Messrs Fischer in Nordhausen; a festoon drying installation being normal for wallpaper printing presses (Fig.44).

Karl Löhr, one of the managers of the Deutsche Photogravur AG, reported to the Board on 14 February 1907:[87] 'The Deutsche Photogravur AG acquired from Graphische Gesellschaft in Berlin the rights to manufacture graphic wallpaper rollers on 24 February 1906 . . . The experiments in the photogravure process, which have cost us about DM 10 000 in Berlin, had to be continued in Siegburg. Until these experiments were successful, we could not dream of marketing our products. Towards the end of last year we were not yet in a position to produce first-class quality prints and by this delay we suffered severe losses . . . We plan to produce posters, art reproductions and similar products by the gravure process . . . We have engaged agents in the following cities . . . We have now despatched to our agents samples of our first gravure-printed advertisement . . . We have also sent this print to approximately 200 of the largest firms with an accompanying letter . . . We are negotiating at the present moment with a large firm for the delivery of 2 500 000 art reproductions. The first proofs are now ready . . . We must not forget that with an order of this size the available printing press would be occupied for a full four months.

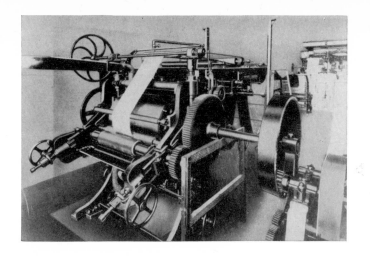

44. Three-colour gravure press built 1906 by SACM for Deutsche Photogravure AG in Siegburg. The photo shows the press at Leeuwarder Papierfabrik a few weeks before it was sold for scrap in 1936.
Collection OML.

Regarding the prospects of our company we can say that they look good. Our colour printing process will be most suitable for advertising posters, but . . . it looks as if we can also get a number of orders for monochrome production . . . After this art reproductions will be our next field of work . . . As soon as we are in a position to produce colour prints we consider that the manufacture of wrappers and luxury papers will be profitable.'

This report is very enlightening in many respects. One can deduce that the Deutsche Photogravur AG could not produce any commercial gravure prints before 1907. In Eder's *Jahrbuch der Photographie* 1908, which appeared by the end of 1908, one finds for the first time monochrome photogravure prints with the imprint 'Gravur und Druck Deutsche Photogravur AG'. In the same volume are further gravure prints marked 'Heliotint Meisenbach Riffarth & Co.' and 'Intaglio Druck von der Hofkunstanstalt G. Loewy in Vienna'.

Gerhard Koch, who died in Siegburg in 1960, told the author that he was apprenticed to the Deutsche Photogravur AG in 1908. He says that a three-colour gravure machine had been installed in January 1907 and that this machine had produced the first three-colour gravure print of a picture 'Salome', before he joined the company. During the winter 1908–9 a second colour gravure print was made, a landscape painting by Corot of which over 10 000 copies were printed. The reproduction was a coloured picture, but could not be described as a facsimile reproduction (Fig.45). The reason for this failure was the unsatisfactory printing inks, and Dr Karl Bleibtreu and Dr Nefgen endeavoured from then on to develop suitable printing inks for colour printing.

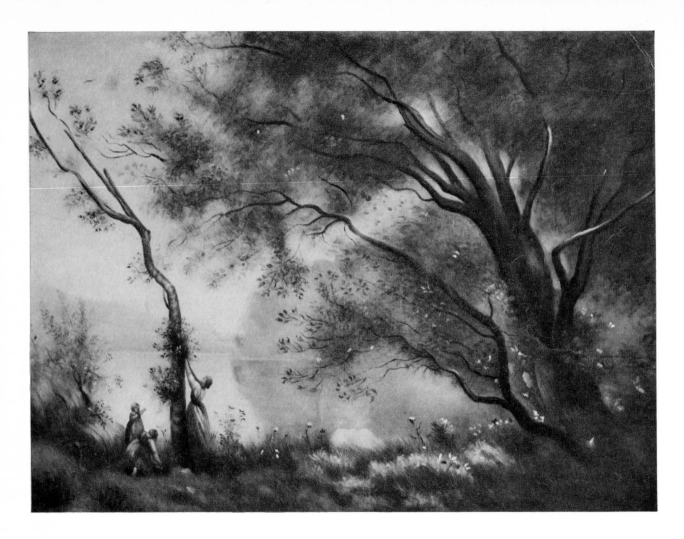

45. The first three-colour gravure print made by Deutsche Photogravure AG, Siegburg, 1909. Collection OML.

The brown and green gravure inks used for the monochrome prints were also made at the factory.[88]

The further development work in Siegburg was intensified under the direction of Dr Nefgen. He concentrated his work on developing a practical procedure in which gravure screen and continuous tone diapositives were exposed subsequently on pigment paper, which were then transferred to the copper cylinder. The result was a method completely identical with the system which had been in daily use since 1895 by Fawcett and Klic in Lancaster under

the name of Rembrandt Photogravure Method, a procedure which was re-invented a few years later by Reich and also in 1904 by Dr Mertens and Dr Schöpff.[89] Despite the knowledge which Dr Mertens had gained, the Mertens Process used invert halftone until in 1912 the method known under the name of the 'Siegburgverfahren' was suddenly introduced also by licensees of Dr Mertens. Simultaneously with the foundation of the Deutsche Photogravur AG, a contract was made between Rolffs and Dr Mertens regulating the rights and duties and, particularly, a division of the income from the sale of licences between the two partners. This contract states that Dr Mertens has the sole right to use the inventions made by both partners for the sale to newspapers, and that he is also general manager for the sale of general licences to jobbing printers. Income from licences taken out by licensees, who print for their own consumption, are divided between Dr Mertens 90% and Rolffs 10%. Licences for the production of pictures in newspapers and magazines are divided 85% to 15%, and licences for jobbing work 50% to 50%. The contract demonstrates that there existed grave doubts as to whether the Rolffs method was suitable for the illustration of newspapers, because the contract contains a clause in favour of Rolffs saying:

'Should it prove in the future that the Rolffs secret process becomes of greater importance than at this moment is apparent, an alteration in the income conditions should be discussed.'

Soon after the foundation of the Deutsche Photogravur AG and following a number of supplementary contracts between Rolffs and Dr Mertens, Dr Mertens concentrated his work on the development of gravure for newspapers. In 1907 he moved to Mulhouse in Alsace, which at that time belonged to Germany, where he founded the Elsässische Textilwalzen-Photogravur Companie. Dr Mertens moved later on to Mannheim, where he founded the Mertens Tiefdruck GmbH. In 1911 a contract was made between Deutsche Photogravur AG and Mertens Tiefdruck GmbH, together with the Rotophot GmbH in Berlin, to found the Rotogravur Deutsche Tiefdruck-Gesellschaft. The foundation of this company did away with the division of interests between the two parties, one of which was predominantly furthering the development of photogravure for use in newspapers and magazines, and the other exclusively confined to art reproductions and other jobbing work.

It is proved by two letters which he addressed to Carl Aller in Valby near Copenhagen[90] that as early as 1907 Dr Mertens was actively trying to introduce his method in newspapers. The letter dated 23 May 1907 says: 'I received your esteemed letter dated 19th of this month and answer as follows:

'The charge for a normal licence, which means not an exclusive right to use my process in your country of Denmark, is 6000 German Mark per year and

for an exclusive licence, 12 000 German Mark. For Norway and Sweden I am not sufficiently covered by patents, but I would undertake to abstain from sales of my process to any customer in these countries, if you require an exclusive licence for Denmark ... This offer is only valid for monochrome gravure. However you have the choice ... to decide if you also would like to acquire the licence for colour printing. In this case the licence fees would be doubled. It must be realized that in view of the potential value of the invention and the enormous cost which I have had in developing the method, I make this very low offer to you because your esteemed firm would be the first one which would use my gravure process for newspaper application ...'

In a further letter dated 5 June 1907 Dr Mertens adds: 'I must tell you first of all that I am not yet in a position to show you colour prints, because the multicolour printing press is just now being put into use. Under separate cover I am sending you a number of monochrome prints. I expect further samples from Siegburg shortly. If the contract is concluded for the total time of the validity of the patents and by payment in cash, I charge the following fees. For a simple licence for monochrome printing exclusively for the use of newspapers and magazines, 50 000 German Mark. For an exclusive monochrome licence for newspaper and magazine uses, 90 000 German Mark. For a simple monochrome licence exclusively for the printing of pictures (post cards, art reproductions and similar jobbing work) 20 000 German Mark. For an exclusive monochrome licence for jobbing printing, 40 000 German Mark. I will not charge a special price for colour printing, as has been my plan earlier on, because colour printing is only in the initial stages of development. Therefore the above named prices should contain the licence for colour printing provided that you assist us in its introduction by allowing me and my representatives and prospective customers from other countries to inspect the process in use in your works, and also supply me with sample prints ...'

It appears that the contract had been signed because the Elsässische Maschinenfabrik supplied the press No.3 to Messrs Aller on 19 March 1908. This press was a single unit reel-fed gravure machine with a re-reeling attachment. Despite the kind collaboration of Mr Claes Aller, the son of Mr Carl Aller, it was impossible to establish when the first prints were produced on this machine.[91] An early print, *The sucking fowl*, a painting by Fritz Henninger, appears to be the first photogravure inset used in *Allers Family Journal*. This print was produced by the use of the Siegburg Process and consequently one can assume that it was produced later than mid-1912.

The machine No.4, made to the order of Dr Mertens, was delivered by the end of August 1908 to Freiburg, where it was installed in the private laboratory of Dr Mertens, in combination with a newspaper printing press made by

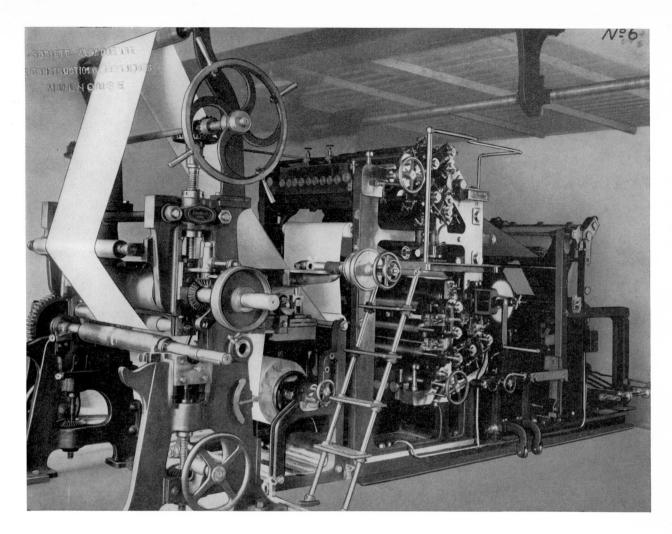

46. Gravure press No.4 from SACM, installed August 1908 in the laboratory of Dr Mertens in Freiburg connected to a Vomag newspaper press. The first number of *Freiburger Zeitung* was printed on this combination in 1910.
Archives SACM, Mulhouse.

Vogtländische Maschinenfabrik in Plauen (Fig.46). In November 1908 press No.5 was delivered to Siegburg. Beginning in 1909 a few monochrome gravure prints made in Siegburg can be found in the graphic and photographic trade papers and annuals.

The next gravure press leaving the works in Mulhouse was delivered in July 1909 to George Newnes in London. The machine was a one-unit gravure press with a mechanical re-reeling attachment. No details about the arrival, acceptance or use of this press have so far been discovered.

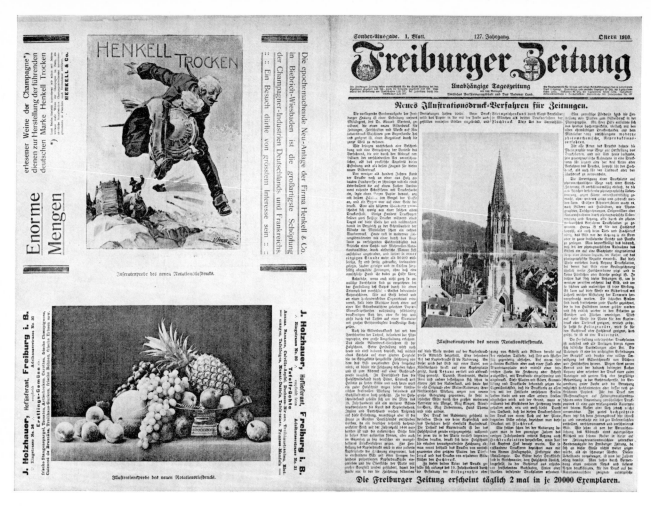

Sonder-Ausgabe. I. Blatt. 127. Jahrgang. Ostern 1910.

Freiburger Zeitung

Unabhängige Tageszeitung

Neues Illustrationsdruck-Verfahren für Zeitungen.

Illustrationsprobe des neuen Rotationstiefdrucks.

Die Freiburger Zeitung erscheint täglich 2 mal in je 20000 Exemplaren.

47. The Easter number 1910 of the
Freiburger Zeitung.
Collection OML.

The existence of the basic patent called 'Screened gravure cylinder' belonging to Rolffs, which was taken out in 1899, was considered a dangerous threat to the development of the gravure department founded by Messrs Bruckmann in Munich, and also to Messrs Meisenbach Riffarth & Co. in Berlin. As pointed out earlier, this patent had been attacked by Dr Mertens in 1904 and Dr Mertens' attempt to destroy this patent was abandoned by the first contract between Rolffs and Dr Mertens in 1906. Bruckmann and Meisenbach Riffarth together started a lawsuit to destroy this patent, resulting in its revocation by the German Patents Office in 1909. Rolffs appealed against this decision in the

highest German Law Court, the Reichsgericht, but the co-owner of the patent, Dr Mertens, took no part in the appeal. In an elaborate and well-considered judgement, the Reichsgericht upheld the destruction of the patent in November 1910 and this destroyed once and for all the priority claims by Ernst Rolffs. The Reichsgericht based its decision on the publication by Brandweiner and also named the British Patent No.1791 of 1865, which protected the use of a crossline screen for Joseph Wilson Swan. Furthermore the Reichsgericht explained that in textile printing as early as in the sixties and seventies of the last century, copper cylinders with crossline designs were common knowledge.[92]

On Easter Sunday 1910 the *Freiburger Zeitung* appeared with two special sections, each of four pages, and in an edition of 20 000 copies (Fig.47). These supplements carried on the outside gravure pictures which were printed on a hybrid press installed in the pressroom. The publisher of the *Freiburger Zeitung*, Max Ortmann, described in this number in a long article the 'New illustration

48. Four-page advertising folder for Mertens gravure process.
Collection OML, presented by Mr Max Ortmann, Freiburg.

methods for newspapers'. Very few details have survived regarding the preparatory work necessary, which doubtless was very complicated. No doubt on account of the effective propaganda work by Dr Mertens, which had been going on for nearly four years, the newspaper publishers in the world were expecting developments which made the appearance of this Easter special number a sensation. Of the extensive advertising work of Dr Mertens a folder has survived, issued in May 1911 by Deutsche Mertens GmbH (Fig.48).

Obviously this sensational Easter Number of the *Freiburger Zeitung* was not a topical newspaper. The edition took a long time to prepare and it was a long time before such a product could be produced regularly. The time necessary to prepare this Easter Number is borne out by the fact that a few of the pictures which appeared in the edition were made from screen diapositives, which had been used by Dr Mertens for his experiments several years earlier. Prints of these pictures have also been found on earlier proofs.

The next edition of the *Freiburger Zeitung* carrying gravure illustration is dated May 1910 (Fig.49). In this edition, which is important from the point of view of the history of photogravure, some remarkable information can be found: '... The special edition of today ... is particularly valuable because a process house outside the organization of the *Freiburger Zeitung* ... Messrs Brend'amour Simhart & Co. in Munich and Dusseldorf have produced the screen diapositives used.' The number contains a very large number of reviews of the first appearance of the Easter Number. For example, the *Zeitungsverlag*, the official organ of the German newspaper publishers, is quoted as having commented: '... The special edition of the *Freiburger Zeitung* has been a great surprise for laymen and also for printing experts. The edition caused a storm of enthusiasm ... The printing formes are steel cylinders covered with an extremely thin galvanic layer of copper only a fraction of a millimetre thick ... For the sensitization of the cylinders a patent of Mr Ernst Rolffs in Siegburg is used ... To facilitate the general introduction of Dr Mertens' process ... three types of machine will be supplied:

(1) Gravure reel-fed presses, with variable scissor cutting, for the production of gravure prints in sheet form. These prints can later on be printed with captions in normal sheet-fed letterpress machines.

(2) Gravure machines in which the web is first printed in photogravure and then enters a normal newspaper press, to be printed with the newspaper topical text.

(3) Reel-fed machines which combine gravure and letterpress units followed by cutting and folding arrangements ...'

In August 1910 the third special edition of the *Freiburger Zeitung* appeared, still printed only on one side with gravure illustrations.[93] This edition contained

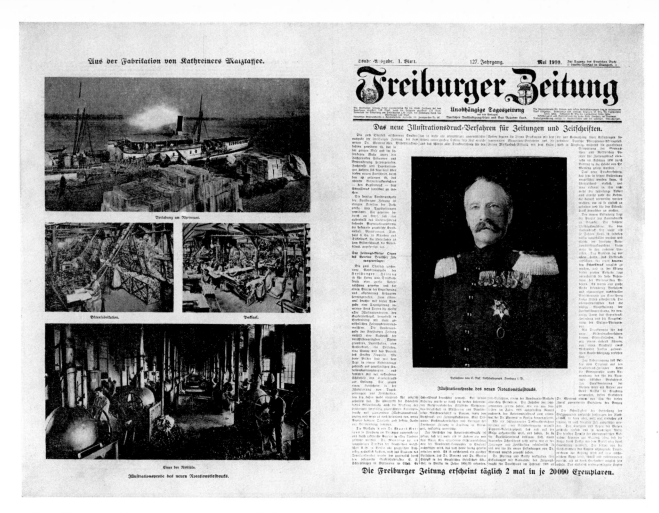

49. May edition 1910 of the *Freiburger Zeitung*. Collection OML.

a verbal report of a paper read by Dr Max Ortmann to the General Assembly of the Deutsche Buchdruckerverein in Stuttgart a few weeks earlier. Dr Ortmann enumerated the newest developments which avoided the necessity of copper-plating the iron cylinders. 'Messrs Elmores Metal Aktiengesellschaft now supplies copper cylinders several millimetres thick, which can be fitted to mandrils by means of a very simple mechanical arrangement (Fig.50).[94] The machine is built in such a way that the diameter of the copper tubes can be extended so that the final copper cylinder always has the same circumference corresponding to the diameter of the stereo plate cylinders in the newspaper

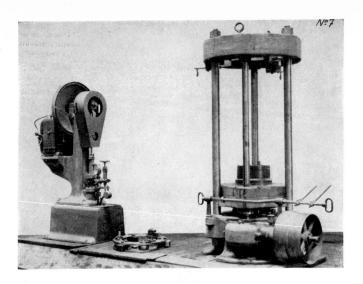

50. Hydraulic press for fitting thin copper sleeves to cast base cylinders made by Elmore Metals AG. From an offer for gravure equipment from SACM. Price, 8700 Mark. Collection OML.

press.' And he says further: 'After changes in the equipment in Freiburg we have succeeded in increasing the printing speed to 12000 revolutions per hour without any loss in quality of the pictures ... The set-off of the gravure ink has been completely eliminated by the very intensive collaboration of several important ink makers ... It was possible to produce a gravure ink which by its extreme drying speed ... avoids any danger of smearing or off-setting.'

The excitement caused by these first gravure illustrations in a newspaper was enormous. The list of the gravure presses delivered during the next few months by the Elsässische Maschinenfabrik shows how important this development was considered by the newspapers.

On 19 September 1910 the *Hamburger Fremdenblatt* announced under the title '*Hamburger Fremdenblatt* with illustrations in gravure' that it had bought a Mertens gravure licence, and that in the course of the next few months the first illustrations using the copper gravure method would appear in the *Fremdenblatt*. But not before 19 March 1911 was it possible to issue the newspaper, which in sections 4 and 5 on pages 17, 20, 21 and 24 carried illustrations in gravure (Fig. 51). The paper commented: 'Next month we hope to be the first newspaper to have come close to the aim which all newspaper publishers wanted to achieve, and to come out daily with a newspaper with gravure illustrations' (Fig. 52).

The *Frankfurter Zeitung*, which received in September 1910 the first perfecting press built in Mulhouse, appeared with four whole-page ads printed in gravure on Sunday, 19 February 1911 (Fig. 53). On the front page of the fourth morning

edition an article appeared occupying two full columns with a description of Mertens gravure process. This article again mentions Ernst Rolffs as inventor of the coating machine. The printing press is a Duplex machine capable of printing illustrations on all pages of a section containing two to eight pages. The press is described correctly as the first machine of this type. Some more details are released about the printing inks: 'The ink suitable for the gravure process has been developed by the ink makers Fabrik für Buch- und Steindruckfarben Gebr. Schmidt in Frankfurt-am-Main – Bockenheim und Berlin-Heinersdorf' (Fig.54). In the same way as in the first editions of the

51. The first edition of the *Hamburger Fremdenblatt* with gravure illustrations, 19 March 1911. Collection OML.

Hamburger Fremdenblatt

Handels- und Börsenblatt · **Hamburger Abendzeitung** · Schiffahrts-Zeitung ·

Weltausstellung Turin 1911: Großer Preis

Der Verlag
des
Hamburger Fremdenblattes.
K. B. B.

Hamburg, 19. April 1913

London

...ahme auf das Schreiben der

...7. de. Mts. bitten wir, dem

...ieur Herrn O. K ü s t e r, die

...m.b.H., Berlin, gelieferten

...emühung im voraus bestens dankend

mit Hochachtung

Publishers of "Southend-on-Sea & District : Historical Notes." 323pp. 5s. net.

TELEPHONE: No. 282 SOUTHEND-ON-SEA. TELEGRAMS: STANDARD, SOUTHEND-ON-SEA.

JOHN H. BURROWS & SONS, Ltd.,

PROPRIETORS.

Directors:
JOHN H. BURROWS
(CHAIRMAN)

JOHN WM. BURROWS
(MANAGING DIRECTOR)

HENRY H. BURROWS

Secretary:
W. TUCK POCK

"Southend Standard," "Grays & Tilbury Gazette,"
"Southend Telegraph."

"Standard" Printing Works,

Clifftown Road,

Southend-on-Sea.

Oct. 22nd 1912

...remely sorry that we
...r trip as suggested, as
...ade an appointment with
...bury. We propose to
...t to Berlin on Sunday
...morning, at least, in
...ould let us have a
...tion to your friends at
...by Mr Langley Jones
...& smooth matters
...us
...you for your interest in

...ith R.Bully,

Henry H Burrow

L'ILLUSTRATION

JOURNAL UNIVERSEL

Adresse Télégraphique
Illustration - Paris

TÉLÉPHONE 139.39
 111.59

13, Rue Saint-Georges, Paris-9e

le September 11th 1912

Dear Mr Ingram,

Mons. A. Chatenet C.E., Manager of our
Printing Department, will have the honor of
calling upon you on Tuesday next, 17th inst.
You will very greatly oblige me by authorizing
Mons. Chatenet to have a look at your
heliogravure plant and thanking you
beforehand for any courtesies extended to him,
I remain, Dear Mr Ingram,
Yours very truly
R. Baschet

52 (left). Three letters from early gravure users, Kurt Broschek, of the *Hamburger Fremdenblatt*, Henry H. Burrows, of the *Southend Standard*, and R. Baschet, of *L'Illustration*. Collection OML.

53 (right). From the first number of the *Frankfurter Zeitung* with gravure illustrations, 19 February 1911. Collection OML.

Freiburger Zeitung, the first numbers of the *Hamburger Fremdenblatt* were produced
on single unit presses. The first perfecting press built in the Mulhouse factory
was delivered to the *Freiburger Zeitung* in November 1910 (Fig.55).

At this time Rolffs and Mertens had again separated following their
collaboration which had originated in the contracts of the years 1905 and 1906.
That is the explanation why Dr Mertens did not participate in the attempt to
alter the decision of nullification of the basic patent 'Screened gravure cylinder'
whose co-owner he had been since 1905. If one looks further at the enmity
displayed by the Deutsche Photogravur AG in Siegburg towards the very fast

development of the Mertens gravure method and the pamphleteering against Mertens' achievements, it is impossible to assume that any collaboration still existed. Also, the fact that in all descriptions of the Mertens process published in the newspapers using the method[95] Rolffs is described only as the inventor of the cylinder coating machine seems to indicate that the sole connexion between Siegburg and Freiburg was the existence of this patent.

In May 1911 the Deutsche Photogravur AG published a four-page pamphlet of historical facts regarding the development of the gravure screened cylinder in Germany (*Geschichtliches über die Entstehung der Tiefdruck-Rasterwalze in Deutschland*) (Fig.56) which displays an indescribable animosity not only against Mertens and his successes, but also against the work of Brandweiner and Klic. Finally even Professor Dr Miethe was attacked, which is more than surprising

56. Four-page pamphlet *Historical facts*, issued by Deutsche Photogravur AG in May 1911.
Collection OML.

because Rolffs ought to have been extremely thankful to him for the enormous assistance which he received from him in 1902.[96] At that time Rolffs began to be interested in three-colour printing on textiles. It is in no way surprising that in this same pamphlet Rolffs also attacked Carl Blecher, who published together with Hermann Kempe in the house journal of the Kempewerk in Nürnberg, *Der Stereotypeur*, well-informed articles on screen gravure from September 1910, and continued to contribute instructive descriptions regarding the history, development and technique of the reel-fed gravure process. Dr Blecher is the man who, after the foundation of the Deutsche Photogravur AG, went to Berlin with Dr Nefgen to spend some time in the Graphische Gesellschaft, in order to obtain an insight into the technology used by Dr Mertens and Dr Schöpff for handling pigment paper in the production of gravure cylinders. In 1907 Blecher had left the Deutsche Photogravur company for reasons which have not been explained. In 1908 he published an extensive book in which he explained in detail the theory and practice of etching of gravure cylinders using gelatine relief resists.[97] It is noticeable that Blecher says in the introduction to his book: 'It is to be deplored that several very important developments in process work cannot be discussed in this book, because the author is bound by contractual prohibitions resulting from his previous employment.' It is obvious that this remark refers to the developments which were at that time going on in the industrial application of the Mertens gravure method and the Siegburg process.

In the beginning Mertens as well as Rolffs had worked with invert halftones. Both used cylinders coated with a sensitive fishglue layer which, after exposure and development, was made acid-resistant by a burning-in process. The sensitive coatings were exposed under screened positive pictures on strippable collodium layers. Dr Schöpff experimented in the Graphische Gesellschaft in Berlin with the transfer of pigment paper, which was exposed separately under a crossline gravure screen and a continuous tone positive picture. Mertens, however, continued the original method of using halftone pictures for printing down on to the direct coated cylinder, as long as he went his own way. He also confined himself to the printing of pictures. Until the middle of 1912 all magazines and newspapers using the Mertens process used gravure for the printing of pictures only and letterpress for any text matter. Towards the end of 1905 the Deutsche Photogravur AG, after extensive and very costly experimentation, came out with continuous tone gravure apparently using the technique previously developed by Samuel Fawcett and Karl Klic. In the middle of 1912 all the interests of Dr Mertens and the Rolffs group were again combined, through the initiative of Mr Hans Kraemer, of Rotophot in Berlin, and all customers of Dr Mertens acquired the right to use the Siegburg method,

which within a few months became the generally accepted technology for gravure printing. We know now that the Siegburg process was completely identical to the Rembrandt method, developed and used in Lancaster nearly twenty years earlier. The 'Mezzotinto Gravure' produced by Bruckmann in Munich, the 'Intaglio Prints' by Loewy in Vienna and the 'Heliotint Prints' produced by Meisenbach Riffarth in Berlin were also made by methods in every respect identical to the Rembrandt process.

The use of pigment paper as transfer medium made it possible to etch text and pictures simultaneously. Dr Mertens patented this idea based on the development work of Dr Schöpff in 1904.[98] This patent claims that the text also has to be screened to prevent the type being damaged by the action of the doctor blade. Nevertheless the Deutsche Photogravur AG in Siegburg and in particular Dr Nefgen, must be credited with having introduced Dr Mertens' and Dr Schöpff's ideas into practical use.

Under the effective direction of Dr Nefgen real continuous tone gravure, which is known today as depth-variable gravure, was introduced from Siegburg. There is no doubt that at the time the continuous tone rendering of the tone values in pictures used in the Siegburg method gave greatly superior results to Mertens' use of a halftone gradation, which could be used only from the light to the middle tone. After the combination of the various interests following the foundation of the Rotogravur Deutsche Tiefdruck GmbH, and in particular through the energy of its director, Hans Kraemer, of the Rotophot Gesellschaft für Graphische Industrie in Berlin, the Siegburg process was rapidly introduced into the work of all Mertens' licensees.

After the *Hamburger Fremdenblatt* had changed over to the Siegburg process in May 1912, Rudolf Mosse in Berlin started his trials for the gravure production of the supplement *Der Weltspiegel*, which appeared twice a week with the *Berliner Tageblatt*. In October and November 1912 long runs were printed as final trials before the regular appearance of *Der Weltspiegel* began with an edition of 12 December 1912. This first newspaper gravure supplement appeared every Sunday and Thursday with eight pages in a quality which would be perfectly acceptable today. *Der Weltspiegel* was printed on two perfecting machines supplied from Mulhouse. At the time the Rotogravur Deutsche Tiefdruck GmbH wrote a triumphant letter to Mr E. H. Rudd, of the *Illustrated London News*, who was at that time experimenting with the printing of his magazine using a Johannesberg perfecting machine. The letter stated that Mosse had succeeded in printing an edition of 240 000 copies of *Der Weltspiegel* on their two machines running at 13 000 cylinder revolutions per hour, and that each cylinder printed its edition of 120 000 copies without any wear whatsoever.[99]

In the June number 1910 of *Der Stereotypeur* Hermann Kempe reports that in Summer 1908 Carl Blecher appeared in the Kempewerk and convinced him and his father, Carl Kempe, in a discussion lasting several hours that they should get together to build a gravure machine, which would be destined to make gravure methods popular with printers.[100] The result was the design of the first sheet-fed gravure printing press, which was presented to the trade in the same article by saying: 'We are offering a gravure press which is not more expensive than a good letterpress two-revolution machine . . . and which makes it possible to print in first-class quality any length of run at competitive prices. To succeed in this it was necessary to get away from the principle of the reel-fed press which hitherto has been thought of as an essential necessity for successful printing of gravure cylinders . . . so that our machine prints on sheet paper (Fig.57). Further it was necessary to simplify the method of using the cylinders . . . jobbing printers . . . can lay down no laws . . . to fill up the cylinder surface. If an order was economic regarding the etching of a gravure cylinder for one or only a few pictures, which do not fill the whole cylinder, in reel-fed printing the paper consumption . . . would be the same as required for a completely filled-up cylinder. In using the sheet-fed principle we make it possible to use a part of the cylinder length and we use only paper in the size really required. Further we eliminate completely the necessity of extensive drying apparatus . . . because we interleaf simply . . . a drying paper by hand. The machine produces 600 prints per hour . . . '.[101]

Many are the reasons which led to the establishment of the close collaboration between Dr Mertens, Siegburg, Freiburg and the first gravure supplier's group in Berlin. These were mainly the nullity declaration of the patent of 1899 and the enormous interest which was caused by the early successes of the development work of Dr Mertens, together with the great activity of several printing press manufacturers and printing houses in the field of gravure. The concentration began by an announcement in the trade paper *Der Stereotypeur* dated 1911: 'The Kempewerk announces that it has concluded a contract with the Berlin Rotophot Company and the publishers Bong & Co. to establish a research laboratory and gravure sales organization under the name of Tiefdruck GmbH.'[102] A few months later the Rotophot Gesellschaft für Graphische Industrie in Berlin undertook an internal reorganization and in June 1911 Rotophot and Deutsche Photogravur founded a company called Rotogravur Deutsche Tiefdruck GmbH in Berlin.[103] The purpose of this company was to centralize the supply of reel-fed gravure presses, the supply of inks, paper and all accessories for all gravure processes for which the Rotogravur had the right to sell licences. The Rotogravur was to act as agents of Rotophot and Deutsche Photogravur for the supply of polished and etched gravure cylinders, and

57. Kempe Blecher sheet-fed gravure press.
Illustration from supplement to the *Illustrated
London News* of 8 February 1913.
Collection OML.

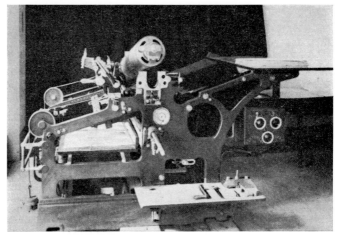

undertook to advise on the installation of cylinder-making departments for
licensees. The contract parties undertook to train the personnel of licensees in
their own works. Further it was arranged that the Rotogravur had the right to
sell or licence abroad the new process patented by Rotogravur, concerning
the double-sided gravure printing in which pictures and type were printed
simultaneously in a perfector press, and that each of the partners had the right
to use this process in their own works free from fees. There were certain
restrictions in this contract, mainly concerning profits which accrued at the

Deutsche Photogravur from its exclusive right to the mercantile use of the Mertens process by the Mertens Tiefdruck GmbH in Mannheim. This contract was signed for Rotophot by the Chairman of the company, Mr Hans Kraemer, for Deutsche Photogravur AG by their managers Dr Nefgen and Wilhelm Gosling.

An internal report exists from one of the managers of Deutsche Photogravur to the Chairman of the Board which explains why Rotophot was extremely interested to gain access to the gravure business.[104] This report explained that the financial strength of the Rotophot was excellent and that the profits had increased continuously during the previous few years. 'There is no doubt that the Rotophot has an extremely great interest in coming to terms with us because their main product, the mass production of genuine photographic prints, is going to suffer severely from the competition of the new reel-fed gravure and because the prices for the products of the Rotophot have now reached the lowest possible figure, in view of the extremely expensive raw materials. It must be realized that the turnover of the Rotophot was two and a half million German Marks in 1910 . . . The proposed contract visualizes an even division of the profits. It must be realized that we do not own most of the old patents any more and that the technological basis for the new applications is not very sound. There is a much greater chance that we will be granted the patents if the Rotophot Gesellschaft and also the Mannheim Mertens Company are our friends and do undertake not to act against the pending patent application. The Rotophot owns one-third of the shares of the Mannheim Mertens Company.' Mr Hans Kraemer, who was the leading spirit in getting the contract accepted, soon succeeded in putting the gravure interests on a firm footing. In September 1911 Rotogravur and Mertens Tiefdruck GmbH in Mannheim combined to exploit all their inventions and patents concerning gravure printing in the field of newspaper and magazine printing, as well as for jobbing printing in Germany. Excluded from this combination were the applications of gravure to textile and American cloth production. In view of the existing contract between the Mertens Group and the Elsässische Maschinenfabrik in Mulhouse regarding the design and delivery of gravure presses, and another contract with Elmores Metal AG in Schladen regarding supplies of cylinders and cylinder-handling machines, the contract stipulated that Mulhouse had the right to deliver at least 50% of the press requirements of Rotogravur and that Rotogravur, Dr Mertens and Mertens Tiefdruck GmbH were each to receive one third of the licence fees paid by Elmores Metal AG.

Neither Dr Mertens nor the Deutsche Photogravur AG were direct partners in this contract, but they each agreed to the validity of the contract. It was specially laid down in the contract, to the advantage of Dr Mertens, that the

clause that each party undertook not to protest against any patent application became void, if this contract was changed in any way without the express agreement of Dr Mertens. The contract also contained a penalty clause stipulating a payment of 5000 German marks to Dr Mertens if, in negotiations, announcements and contracts which concerned Mertens' patents, these patents were not expressly named as such.

No folders or sheet deliveries were in the production programme of Elsässische Maschinenfabrik. Therefore this firm agreed with the printing press manufacturer Koenig & Bauer in Würzburg[105] that both firms should deliver gravure machines in such a way that all units were built in Mulhouse and that the cutting, folding and delivery equipment was built in Würzburg. Soon the Rotogravur Company became a partner to this arrangement but reserved the right to have the contracts respected, which in the meantime had been made between Siegburg and the printing press manufacturer Johannisberg in Geisenheim. The first machine built under this contract in Mulhouse and Würzburg was delivered to the *Hamburger Fremdenblatt* in May 1912.

By December 1912 negotiations between the different groups had progressed far enough to extend the collaboration existing in Germany to include the whole world. First of all, a contract between Dr Mertens, Deutsche Mertens GmbH in Freiburg and Rotogravur Deutsche Tiefdruck GmbH in Berlin stipulated[106] that all steps which had been taken so far in England to fight patent rights belonging to one of the contract partners had to cease immediately. The group combined from now on in the interests of safeguarding all rights and assisted each other, in particular against attacks from third parties. At the same time the Internationale Tiefdruck GmbH in Berlin was founded. Dr Hans Kraemer was made sole manager. All patents, rights and experiences available to the contract partners regarding gravure processes, with the exception of textile, American cloth, linoleum, wallpaper and paper for packaging, were brought into the new group, including all inventions still to come. Furthermore Dr Mertens and the Rotogravur Company brought into the Internationale Tiefdruck GmbH all partnership rights which they owned in their English companies, and in the same way the Rotogravur contributed the 50% shares it held in the sales organization in North America, which had been founded earlier.

This complicated reorganization soon proved unsatisfactory, in view of the extreme diversification of the existing contracts. In the summer of 1913 Hans Kraemer succeeded in achieving the final step by founding the Internationale Tiefdruck Syndikat on 2 May 1913. This holding company now combined all the firms that had been founded which had any connexion with the Rotogravur organization and the Mertens group. The Tiefdruck Syndikat took the form of a limited company (GmbH). It was founded with an initial capital of 96000

German marks which were divided in the following way between the founder firms:

Internationale Tiefdruck GmbH in Berlin	German marks	8 000
Mertens Tiefdruck GmbH in Mannheim		8 000
Rotogravur Deutsche Tiefdruck GmbH in Berlin		8 000
Tiefdruck GmbH in Berlin		4 000
Kempewerk oHG in Nürnberg		4 000
Elsässische Maschinenbau Ges. in Mulhouse		16 000
Maschinenfabrik Johannisberg in Geisenheim		16 000
Schnellpressenfabrik Koenig & Bauer in Würzburg		16 000
Maschinenfabrik M A N in Augsburg		16 000

The managing director of the firm was Hans Kraemer and the Board was composed initially of Alfred Reise, Ernst Brinkmann, Dr Willy Martin and Dr Eugen Barella. The company rules[107] state the purpose of the Syndikat: Utilization by means of sale of licences and production of all machinery and equipment based on patents and technical knowledge available to all the founding firms, including all patents or rights or secret processes coming to the knowledge or into the property of the contracting founder firms, relating to the production of gravure printing from cylindrical printing formes.

During the next few months two further firms joined the Tiefdruck Syndikat and by November 1913 the Syndikat had come out into the open with a circular letter (Fig.58), which meant the end of the development work of Dr Mertens, as well as of the Deutsche Photogravur AG. A highly active time for the Syndikat now ensued under the direction of Hans Kraemer, which was

58. Announcement of the foundation of the Internationale Tiefdruck Syndikat, November 1913. Collection OML.

suddenly interrupted by the outbreak of war in August 1914.

Nothing authentic could be established regarding the further development of the Mertens companies, and also no details have been unearthed as to how these companies were disposed of after the untimely death of Dr Mertens in 1919.

Something more is known regarding the fate of the Deutsche Photogravur AG. Over and above its day-to-day production of rotogravure printing, this firm ran an experimental and teaching department in collaboration with Rotogravur and Internationale Tiefdruck GmbH, which had been started in 1913. A large number of printing technologists from all over the world were introduced to, and trained in, the intricacies of the gravure process during the following twelve months.

A report[108] by Mr Rolffs to the Board of Management of the Deutsche Photogravur AG dated 15 June 1912 demonstrates dramatically the enormous difficulties and old-fashioned methods one had to contend with in this firm, compared with the more modern installations used by the newspaper publishers. This report was apparently made to oust Dr Nefgen from the technical management. It is extremely interesting to see that some of the technical problems which were besetting gravure plants as early as 1912 are the same which to some extent are still discussed today in modern gravure printing houses. Rolffs reported: 'The photographic department works fairly satisfactorily, but some of the diapositives could be still much better. Extensive experimentations and discussions are held regularly to avoid making mistakes and to introduce improvements. Retouching is also somewhat better than it used to be. But it is difficult to reproduce pictures of machines and factories and it is suggested that a special retoucher be engaged to be trained in this field. There is still a dearth of retouchers. Laying of pigment paper: The results are quite acceptable, but during summer-time it appears that there are serious faults in screening of the pigment paper, the reasons for which have not been discovered. Etching department: Several years ago Dr Nefgen was put under pressure to run this department with two etchers. However this has not yet been achieved. Consequently the etching department is heavily overloaded with work, particularly during the time when demonstrations have to be made. The result is that an undue number of cylinders must be repeated. Discussing these problems with Dr Nefgen recently, he maintained that a second etcher has been engaged. However this man is far too valuable to be used as an etcher and no doubt he will soon fill the position of etching-room overseer and will cease to do practical etching. A young man should be engaged as etching apprentice. The pressroom is still suffering from teething troubles regarding output and economic working. The speed of the press is unsatisfactory. The slow printing

speed is sometimes necessary because the festoon drying arrangement following printing is inefficient, and drying of the pre-moistened paper takes such an enormously long time. This results in the presses often standing idle for four to five hours per day. Lack of cleanliness and lack of organization result in lost time and faulty printings. Also poor organization regarding the timely ordering of paper, cylinders, spindles and other machine parts is the reason for delay in deliveries. Experiments to improve the drying have so far not started. The drive of the festoon dryer needs replacement. Bad organization regarding the perfector machines is to be deplored. We have orders to keep these machines occupied for four months; despite this Dr Nefgen intended to change the existing old machine into two single unit presses. I prevented this happening in a discussion several weeks ago and asked Dr Nefgen to do his utmost to re-use this machine for perfecting. Three and a half weeks ago, when I took over the general management of the firm, nothing had been done. Spindles, cylinders and other parts are missing and the driving motor is not strong enough. The biggest fault is the absence of a tension arrangement for the felt blanket. The ink department needs a thorough reorganization. No report book is kept, either for the mechanical or the chemical departments. The consequence is that all the very expensive and valuable results of experiments are the property of Dr Nefgen instead of the property of Deutsche Photogravur AG. Dr Nefgen undertook after many admonitions to instal such a book which he is bound to under his contract, but nothing has been done. Dr Nefgen also occupies all departments in the interest of the licensees, despite the fact that he has no right to do so. I have now started a technical conference, meeting twice a week, to speed up the execution of orders which we have. These conferences are held with all departmental managers being present, so that each one knows which is most pressing and what has to be done to assure a satisfactory flow of work. Whenever I spoke to Dr Nefgen he said that everything was in good order, but whenever I became more insistent, requiring information regarding poor or slow delivery, he was never prepared to answer such questions, despite the fact that he has worked for more than six years in our factory. This prevented immediate action to remedy any shortcomings. Several of the failings of Dr Nefgen have persisted for several years. Since the Rotogravur has been founded, Dr Nefgen, whose interest and industry must be acknowledged, has been rather overloaded and by this fact the rentability of the Photogravur Company suffers noticeably. The result of last year's activities is poor. We cannot afford to face further losses because Dr Nefgen is fulfilling other duties, and therefore I have taken over the technical management of the factory myself. It is essential that we should insist that Dr Nefgen concentrates his activities on the improvement of the technical production. I suggest that Dr Nefgen is

informed during today's meeting that we have decided that he must refrain from any activity in the technical management of the Photogravur Company.'

From then on Dr Nefgen could concentrate his activities on instruction and consultation of the licensees, which he did with outstanding success. Rolffs took over the technical management of the Deutsche Photogravur AG, but under Rolffs's direction not very much changed in the course of the next few years. The minutes of the commission meeting dated 17 August 1913 throw a harsh light on the completely unsatisfactory organization within this firm on the one hand, and on the other hand are extremely interesting, if one compares the technical problems which were discussed during the meeting with those problems which occupy the meetings of photogravure printers even today. The accountant who took part in this meeting raised objections complaining that it was difficult from the accountant's point of view to differentiate between work done in the factory according to its uses. Consequently it was decided to divide the work going through the mechanical shops into jobs for new installations, for the normal production of prints and for experimentation. Each job was to be given a job number. An attempt was to be made to divide the cost of experiments made by the Photogravur Company between the newly founded Internationale Tiefdruck GmbH and the Rotogravur. It should be essential that all chemicals to be used should be tested in the chemical laboratory before they were allowed to be used by the production departments. It had been noticed that during the previous months a large number of cylinders showed porous areas. Such porous cylinders should not be used for etching, but should be returned to the plating department. The buying had to be centralized to enable an easier control and supervision. The exceedingly large consumption of cleaning rags was very costly. In place of the cleaning rags for cleaning cylinders, the use of a squeegee or even a doctor blade in the press to rotate with paraffin or similar solvents should be tried. Similar procedures were to be adopted in the etching department. In the pigment paper department it was essential to keep a record of how much paper was sensitized and how much of the sensitized paper was actually used on each job. An investigation was to be made into the costs of the preparation of screens to establish if the price asked for the screen was economical. Dr Kienitz was to be asked to submit a report on his screening experiments. Regarding doctor blades, it was to be considered if it was not advantageous also to supply doctor-blade steel to Rotogravur. The experiments started by Dr Bleibtreu with printing inks were to be continued. Regarding the large number of unsatisfactory diapositives, Dr Nefgen asked if any control was exercised regarding the suitability of the diapositives for further use. It was essential to accept as a principle that no cylinder should be laid without the planning and individual diapositives having previously been

checked by competent persons and having been passed as suitable. Furthermore no cylinder must be etched whenever prior to etching any fault or shortcoming could be recognized on the cylinder itself, or during transfer and development, because it was useless to attempt an etching in the hope that the observed fault would remedy itself. A monthly report was required regarding all faults which appeared during the previous month for a detailed discussion in committee. It was noticed that a very large number of cylinders were unsatisfactory and discussion was essential to establish a method to prevent the large number of repeats. In this context Dr Nefgen suggested: 'It is essential to standardize the production as far as possible. To achieve this it is necessary that standards for the diapositives are strictly adhered to, furthermore that only one printing lamp is used for the exposure of the pigment paper, which must be carbon arc. Strict standardization of the exposure time has to be introduced and also the same type of pigment paper must be used at all times. A further essential is a strict control of the development of the pigment paper regarding temperature and time, and that no changes are allowed in the composition of the several etching baths. Furthermore it is necessary to lay down the rule that no experimentation has to be made whatsoever during production, and the production procedure must be completely standardized to the methods and data once they have been recognized as being suitable. This is particularly so for the composition of the iron perchloride solution and the type of pigment paper used. Experiments regarding the use of other illuminants have to be made outside the production department. It looks at the present moment as if the diapositives for the colour printing are sufficiently good to be used for extensive experimentation, to try to vie with the advantages which colour printing has in Berlin. Dr Nefgen also thinks that the introduction of the sheet-fed press will be very successful, and believes that the new sheet-fed press acquired from Johannisberg will supersede the use of reel-fed machinery, etc., etc. . . ' (Fig.59).

When and how Maschinenfabrik Johannisberg started to contribute to the development of photogravure have not been clarified. The factory informed the author[109] that it started gravure experiments between 1906 and 1910 by printing from etched gravure plates, which were used in a modified flat-bed machine. The first reel-fed single unit gravure press No.8451 built by Johannisberg had been delivered to Deutsche Photogravur AG in Siegburg in October 1911. Only two years later the first sheet-fed gravure press No.9293 was delivered to Messrs Rotogravur. This press became widely known all over the world under the trade name 'Liti'. The machine was built for many years under the guidance of engineer Albrecht and chief machine minder Fischer. It appears that reel-fed rotogravure machines built at Johannisberg were supplied by Tiefdruck Syndikat exclusively to the United States and that, prior

59. Liti sheet-fed gravure machine by
Maschinenfabrik Johannisberg in
Geisenheim.
From one of the firm's catalogues of 1919.

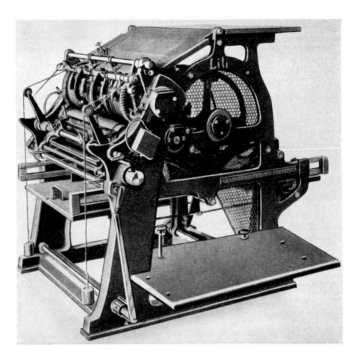

to the foundation of the Tiefdruck Syndikat, apart from the press for Siegburg
already mentioned, only one single perfector press was delivered to the
Illustrated London News in 1912 (Fig.60).

With the outbreak of war in 1914, printing activities and instruction of
licensees practically ceased. After the war the occupation of the city of Siegburg
stopped all work at Deutsche Photogravur AG. In 1923 the company was
dissolved.

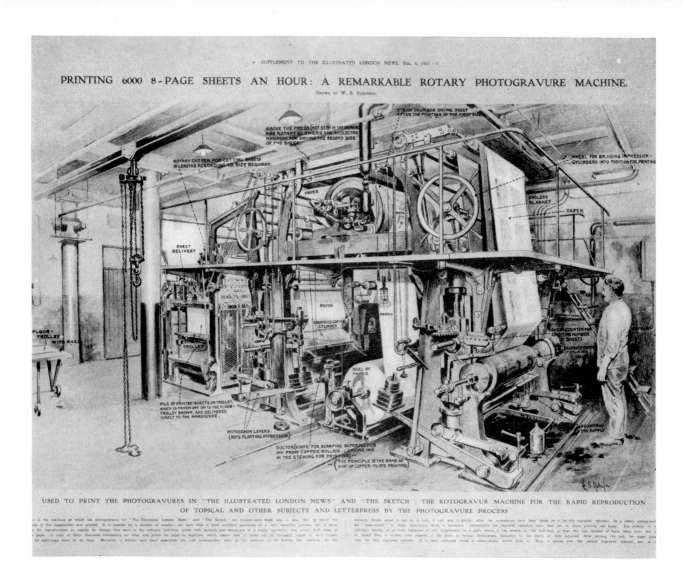

60. Perfector gravure machine with sheet delivery made by Maschinenfabrik Johannisberg for the *Illustrated London News*. Centre spread of supplement 'The Beauty of Photogravure' to *ILN*, dated 8 February 1913. Collection OML.

Schnellpressenfabrik Albert & Cie, Frankenthal

It is a surprising fact that the activities of Schnellpressenfabrik Frankenthal Albert & Cie AG were in no way influenced by the developments in either Sieburg or Freiburg. The development of gravure machines at Albert was based on the design of lithographic printing presses, redesigned to print gravure formes from flat etched plates (Fig.61).[110] The date of this redesign must have been about 1910. The patent granted to Albert[111] describes the invention of a method to avoid smudging the borders of a flat gravure etching. The machine was put on the market under the trade name 'Walküre'. Oberingenieur Konrad and a Munich printer Hans Schulte, who later became technical director of Albert and had profound influence on the design of gravure printing presses until his retirement at the end of the thirties, developed the world-famous sheet-fed photogravure machines which are still marketed today under the name 'Palatia'. The basic design conceptions, which were still used for the construction of machinery in the 1960's, show a surprisingly high technical conception (Fig.62). With the first construction of the 'Palatia' machine, the short period of sheet-fed flat-bed gravure machines came to its end. In 1912 a plate machine 'Walküre' was delivered to Brend'amour Simhart & Co.[112] in Munich, a firm which had some connexion with the developments of Dr Mertens, as this firm made the screen positives for the second number of the *Freiburger Zeitung*, which appeared in May 1910.[113] Brend'amour Simhart told

61. Principle of the German patent No. 241374 of Albert & Cie, Frankenthal, for cleaning the edges of gravure formes shown on the diagram of a sheet-fed plate gravure press.

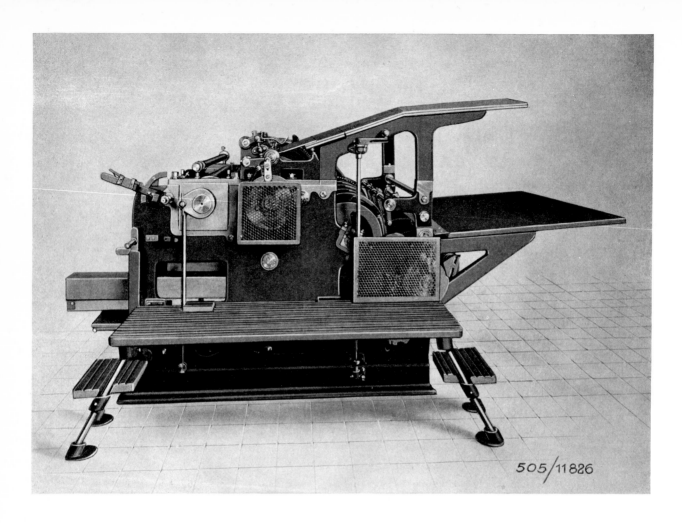

62. Palatia sheet-fed gravure press made by
Albert & Cie, Frankenthal, in 1913.
Photo supplied by Albert & Cie.

the author that experiments in gravure printing of small editions using the
Mertens invert halftone method were not very successful. As late as 1913 large
editions were easy to reproduce in conventional screen gravure using the
Albert 'Palatia'.[114] This machine was the press on which trial prints for
Bavarian postage stamps were made. The unsuccessful tender for the order for
Bavarian postage stamps specially mentioned that the trials were printed on a
press built in Bavaria.[115] Apparently because the installation at Brend'amour
Simhart was considerably smaller than the long-established gravure department
at Bruckmann, the order went to Bruckmann (see page 58).

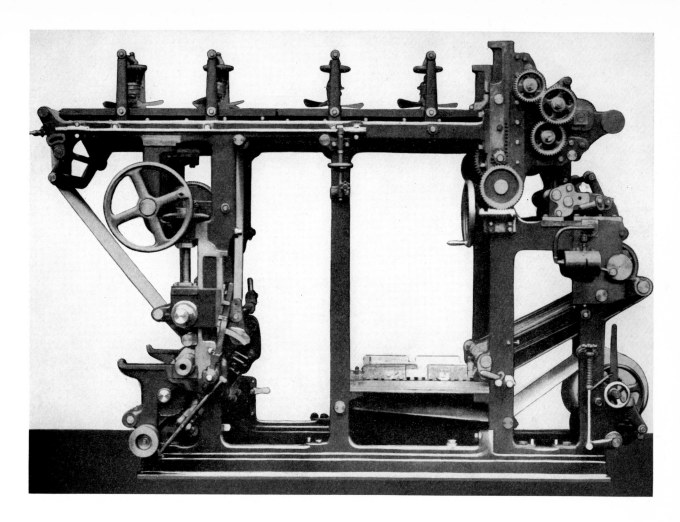

63. Albert-Schulte reel-fed gravure machine
with sheet delivery, built in 1913.
Photo supplied by Albert & Cie.

Hans Schulte did not confine himself to the design of sheet-fed and reel-fed
gravure machines (Fig.63). He also designed the necessary auxiliary equipment
such as laying machines, cylinder grinding and polishing machines. The first
Albert reel-fed gravure machine was supplied to Graphische Kunstanstalt Rohr
in Berlin, immediately followed by a second machine to Fischer & Wittig in
Leipzig.[116] Obviously to avoid patent disputes with the Tiefdruck Syndikat,
the Frankenthal reel-fed gravure machines did not use drying drums, but were
fitted with horizontal heating plates between which strong fans were installed
to speed up the drying process.

Progress in England

There is no doubt whatever that the first practical gravure process was developed and first used in England, even if neither Klic nor Reich were Englishmen. The Czech Klic succeeded in getting his development work accepted by his employers and persuaded them to start a successful business using his ideas. On the other hand, the Austrian Reich and his collaborators, foremost among them Harry Lythgoe who was an Englishman, were forced to take the procedure they had developed in England to Germany, Austria and America, to succeed in its practical application. The appearance in the middle of the nineties of Rembrandt prints on the art market was noted by publishers, art dealers, printers and photographers, and led to extensive discussions in technical circles where the secret details were discussed at great length. It was stated again and again how extremely difficult it was to gain any information about the new secret gravure process. Today it is difficult to understand why this was so, as by 1900 all details were accessible in a few books (see page 33), and minutes of meetings of the Royal Photographic Society and other bodies interested in the graphic arts. Nevertheless, many years elapsed before the re-inventors had succeeded by their own ingenuity in producing a method which could be considered for commercial exploitation. It is not surprising that all successful early gravure printers had some connexion, either knowingly or, more often, unknowingly. We know of a connexion between Klic and Reich through the relations which both of them had with Captain Collardon (see page 58) the owner of the Art Gravure Company in London. A further connexion was no doubt the Swan Electric Engraving Company. Wilson Swan, whose contribution has been discussed earlier (see page 27), had the knack of surrounding himself with men who left their mark on the development of process work in general, and also in several branches of gravure. In his firm we find from time to time Frederick J. Ives and Oscar Pustet, who was responsible for inviting Reich to Austria in later years, and also Alfred Harold Lockington. When Ives returned to Philadelphia he took Lockington with him[117] and employed him in his laboratory for researches in halftone

64. John Allen, 1871–1945.
Photo supplied by The Vandyck Printers Ltd,
Bristol.

reproduction. In this laboratory we also find John Allen (Fig.64) the son of a
London publisher.[118] Soon afterwards W. H. Ward, who was also working in
the Swan company, founded the Printing Art Company in London and engaged
Lockington and Allen for the production of heliogravures. It is only too
natural that both of them used the knowledge they had acquired in the employ
of Ives and tried to use halftone gradations for the production of gravure
printing formes. A little later Lockington joined E. Sanger Sheppard, who at
the time was occupied with experiments and trials in colour photography and
who was responsible for the design of the first practically usable three-colour
separation camera. In 1899 John Allen left Ward and joined the French
heliogravure printer Raoul M. Pelissier working in London,[119] who later in
the twenties occupied a very important position in the gravure industry in
America.

In 1902 Allen and Lockington got together and founded Allen & Co.
(London) Ltd, a firm with a spectacular development. A year later they
employed twenty heliogravure printers, a female retoucher, two girl packers
and two apprentices, in addition to an accountant. The firm specialized in the
production of heliogravure prints for the illustration of books. In 1905 a
Johnson steel engraving printing press[120] was installed to speed up the printing
procedure, more orders having been received than could be executed with the

manual printing methods then used. These prints were marketed by the art publishers Spalding, with the advertising slogan 'A guinea print for half a crown'. The size limitation of this press and also some difficulties with the wiping arrangement induced Lockington to interest himself in the imitation of the Rembrandt prints he knew were produced on a reel-fed machine. The experiments were started with the acquisition of a small wallpaper printing press of unknown design, but the experiments did not succeed. The firm therefore installed a rebuilt French lithographic stone press. At about this time three men, Seelig, Sydney and Heinen, were employed by Allen & Co. who previously were employees of the Art Photogravure Company Ltd (Collardon). This may be pure coincidence. Allen and Lockington have always denied that these three were in any way connected with the development of the gravure process by their company. Nevertheless it is surprising, to say the least, that in 1908 a reel-fed gravure press was delivered to Allen & Co.[121] from John Wood in Ramsbottom. About this time the first Alezzo gravures appeared on the market at intervals. Mr Lockington told the author about the development work and their production:[122] 'After I had studied a large number of Rembrandt prints using strong magnifiers, with the intention of finding out what type of grain or screen was used for their production, I suddenly realized that a crossline screen was overlying the whole picture. The unetched lines compared with the etched areas were extremely narrow. With my experiences in the production of halftones, I succeeded in making on the camera a fine line screen by using a halftone screen with a slot stop. I then made gravure plates. First of all metal was coated with fish glue. I then printed down the line screen twice, angled at 90°, and, after developing, burnt in the resulting crossline net. To the plate prepared in such a way with an acid resisting crossline screen, I transferred an exposed pigment paper and etched as was normal in the grain heliogravure process. To talk about it now is very much simpler than it was at the time. After I succeeded in doing this on flat plates, we made further attempts to use cylinders, but were unable to print from them. After some extensive search we found in Ramsbottom, Mr John Wood, who built wallpaper and textile reel-fed presses and who taught me the use of the doctor blade. But it was far too difficult to apply the required crossline screen to the cylinder, and a long time elapsed till I found out that it was possible to expose the pigment paper not only under the continuous tone diapositive, but also that the crossline screen could be exposed separately on to the pigment paper prior to laying. The greatest problem was to find out the relative exposures between screen and picture, so that the screen lines withstood even the longest etching time required for the shadow tones. But don't believe that these were all the problems. A very difficult problem was the making of the printing ink. We

found it quite impossible to interest one of the printing ink manufacturers in the production of a suitable printing ink. One of the well-known printing ink manufacturers told us that they could not see any future in this affair and we were therefore forced to make extensive experiments to compose a suitable printing ink. The ink must be completely free of any visible particles, but a dye solution also proved impossible to use. We found in the end that the pigment and resin had to be dissolved in a suitable solvent, which could evaporate after the printing. The printing ink must be very highly pigmented and must dry into a hard layer. In the end we found that asphalt served as a suitable varnish and at the same time provided some colour strength. It took us until early 1910 before we had progressed far enough to be in a position to supply Alezzo gravure prints on a regular basis. As soon as we went into commercial production Allen & Co. always protected their etched cylinders by an electro-deposition of a thin steel layer, as was normal for the protection of heliogravure plates. We can claim therefore to have been early forerunners of chromium-plating which is today normal practice in rotogravure.

'About this time the developments which had taken place in Germany made their mark in England, resulting in a large increase of orders with all firms producing heliogravures or machine-printed heliogravures. To find the necessary new capital the Bristol art publisher E. W. Savory, who was one of our largest customers, founded the Vandyck Printers Ltd which soon amalgamated with Allen & Co. In 1912 we started to build a large new factory in Bristol and during that time Mr Savory and myself made a trip to Germany and Austria. Because of my personal acquaintanceship with Mr Pustet, I was able to spend three months working at Messrs Loewy in Vienna to study the methods used in this firm for the production of the gravure prints they marketed under the trade name Intaglio and Intagliochromdrucke.

'In the new factory two new printing presses were installed next to the old Wood rotary press of 1908, and very soon a further press was necessary. All four machines still used the endless felt blanket running round the impression cylinder. Then in 1914 the felt was replaced by a small rubber-covered roller placed between the copper cylinder and impression cylinder. At the same time we bought from Germany a small plate gravure press 'Walküre', which was very suitable to print the highest quality but at very low speed. The plate used in the 'Walküre' press was a twelve millimetre thick steel plate on to which the thin copper plate was fixed by a soldering process. The steel plate was tinned, the etched copper plate was put on the steel support weighted down by heavy weights, and the whole was then heated in an oven till the solder acted. After cooling, the copper plate was fixed to the base completely plane and bubblefree. At Vandyck we also kept everything a strict secret. A very interesting example

of this secrecy can be found in a publicity leaflet which was printed towards the end of the First World War. In this leaflet a picture is reproduced called "Our four gravure presses" (Fig.65). One can see in the picture a wall with four slots out of which appear four webs of paper printed with pictures, which are trimmed into single sheets by young girls using hand trimmers.'[123]

The heliogravure printers were not the only ones interested in developing machine-printed photogravure to increase their output. One of the largest firms in the art postcard and art reproduction trade was Raphael Tuck & Sons. Frederick Thomas Corkett was the manager of the postcard department from 1901 to 1906.[124] In December 1907 a paragraph in one English trade paper[125] read:

65. 'Our four gravure presses.' Illustration from an unpublished advertising leaflet of The Vandyck Printers Ltd, Bristol, 1917. By courtesy of Mr H. N. Beams.

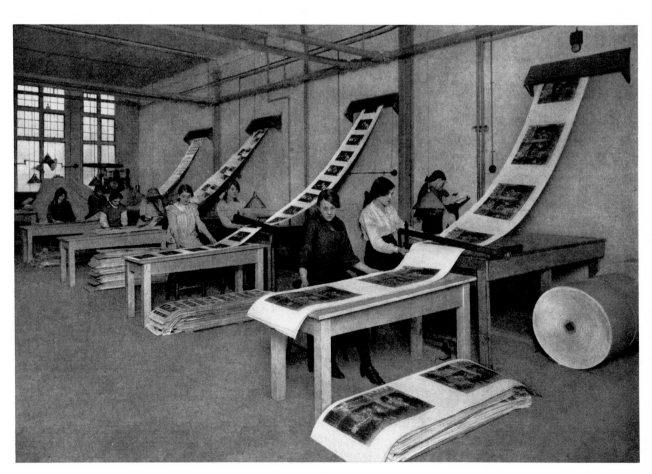

'The Mezzogravure Process, which is a speciality of The Fine Arts Publishing Co. Ltd, is perhaps the highest possible development of commercial machine-printed photogravure. It is not only applied to the publication of pictures, including the well-known Burlington proofs and the recently introduced Burlington Art miniatures, but is also being pushed for commercial purposes in advertising, menu cards, show cards, calendars, etc. This particular branch of the business of The Fine Arts Publishing Co. has recently been placed under the management of Mr Fred T. Corkett, who was one of the pioneers of picture postcard publishing in Leicester, and thereafter managed the studio of Messrs Raphael Tuck & Sons for several years.'

This notice mentions again one of the many contacts existing between the early gravure firms. The trade name Burlington Print was the property of The Fine Arts Publishing Company. The first Burlington Prints were marketed before 1900. They were produced at the Rembrandt Company in Lancaster. From 1905 Bruckmann in Munich was marketing 'Mezzotinto Gravure' prints, which were represented in London by the very active Mr S. Wilensky. There can be no doubt that The Fine Arts Publishing Company not only bought art reproductions from Rembrandt, but also received prints from Bruckmann. Therefore it is only too natural that the manager of the Burlington Print department had close contact with these suppliers. The Fine Arts Publishing Company started to market the first rotogravure printed colour prints under the trade name Mezzochrome in 1908. These prints were produced by the Rembrandt Company in Lancaster.

In 1909 Mr Corkett spent several months in Munich with Bruckmann and bought the right to introduce the Mezzotinto process in England and America. Early in 1910 John Wood supplied a small gravure reel-fed machine to Corkett[126] which was demonstrated in Fleet Street. An English trade paper[127] reported in June 1910: 'Mr Corkett demonstrated his gravure process to the Press. As is normal with gravure methods, this demonstration was shrouded by an impenetrable secrecy. It was impossible to call this a demonstration, because all that the onlookers could see was the long web of paper carrying excellent quality prints which appeared over a screen, behind which one could hear the sound of a running machine. One must assume that the method by which these prints were made is similar to the processes which are discussed extensively in Huson's book.[128] The only obvious thing was that the problems with ink were solved in a different way from that used by the Rembrandt Company and by Mr Saalburg.[129] In Corkett's demonstration the prints were completely dry when they appeared over the screen and had no tendency to rub off, therefore interleaving of the prints after production was unnecessary. The printing speed could be gauged by the number of prints appearing over the screen was in the

order of 1800 prints per hour.'

The demonstration was given to the trade press and only a very few other persons. One of these was Edward Hunter, who later founded the Sun Engraving Company and who describes the demonstration in exactly similar words.[130] Edward Hunter has nothing to do with the Rembrandt employee of the same name, mentioned on pages 48 and 54. Edward Hunter reports that Corkett succeeded in persuading him and his friend A. J. Hughes that there was something in this process. All other printers who saw the demonstration thought that is was purely a swindle. Hunter and Hughes were the owners of the Anglo Engraving Company and they paid Corkett £2000 for the secret. They received a large box containing negatives, diapositives, pigment paper and extremely long handwritten instructions for use. Immediately afterwards Corkett went to America. This was the beginning of the famous Sun Printers in Watford, today one of the largest gravure printers in the world.

In 1906 the Anglo Engraving Company bought a small printing house which had got into difficulties.[131] The only profitable department of this printing organization was a small heliogravure department managed by John Threlfall. A short time afterwards, following the purchase by the Anglo Engraving Company of the scanty information from Bruckmann in Munich through the good offices of Corkett, and after a reel-fed gravure machine made by John Wood was installed in 1911,[132] this company produced gravure prints which were marketed during the next few years under the names Mezzogravure, Anglogravure and Formangravure. The development of the gravure department was extremely rapid. Very soon in addition to the owners, Edward and Noel Hunter and A. J. Hughes, twelve workmen and a large number of female labourers were occupied in producing catalogues, advertising material, etc. The first press delivered by John Wood to the Anglo Engraving Company had a web width of only 16 inches. Very soon two further machines were installed with a web width of 20 inches. A fourth machine added a little later then had a web width of 30 inches. A. C. Larcombe, who was until his untimely death in 1960 gravure manager of the largest English gravure company, Sun Engraving Company, later Sun Printers Limited, the successors of the Anglo Engraving Company, made several very detailed statements regarding the beginnings of gravure in the Anglo Engraving Company.[133] The machines, he said, were very simple but extremely strong. Impression was given through an endless felt which was led over the steel impression cylinder. Every Sunday five layers of manilla carton were glued on to the steel cylinder, which first were carefully smoothed with emery paper and were afterwards varnished with shellac. The paper was always bought in reels of 50 inches width and then trimmed to size using a re-reeler/slitter. During the re-reeling, the paper was dampened and

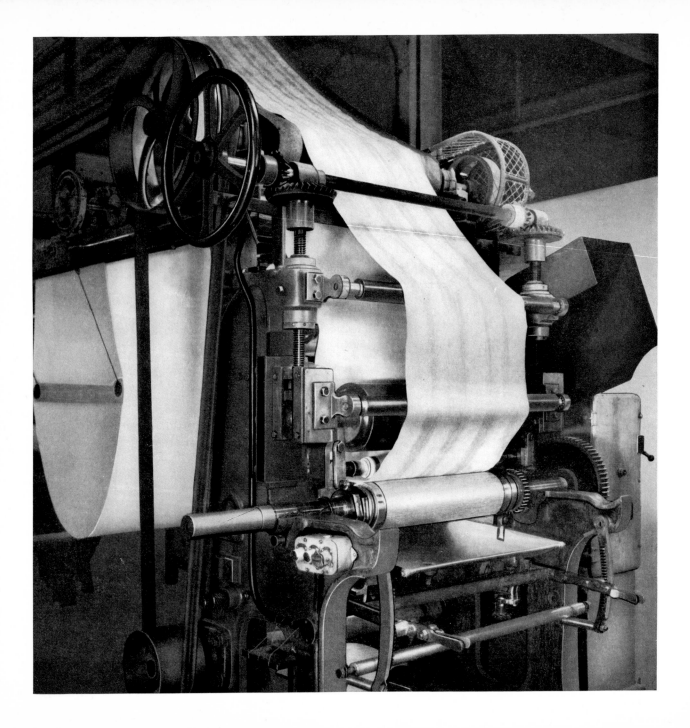

was then left for a minimum of 24 hours before it was used. After printing the
paper was led over a large copper plate fixed near the ceiling, which was heated
by open gas flames to assist the drying, and was afterwards re-reeled on a
large-diameter wooden drum.

The Anglo Engraving Company produced only one-sided monochrome
prints. The web was separated into single sheets in a bookbinding department
according to printed cutting marks and this was done by young girls. Strictest
secrecy was observed. The print room could only be reached by passing through
a set of locked doors. The most important information supplied by Corkett
were the recipes for the printing inks.

The printing inks were made within the factory until after takeover of
Andre & Sleigh in 1918, and after the formation of the gravure department of
the Sun Engraving Company it was the custom to buy in gravure inks from
specialist ink makers. Soon after the *Illustrated London News* changed over to
the use of gravure in 1912, the Anglo Engraving Company produced preprints
for the magazine *Weekly Graphic*. In 1915 the *Weekly Graphic* installed its own
gravure presses which were made by Pickup & Knowles in Manchester (Fig.66).
The cylinder production remained at the Anglo Engraving Company.

An important step in the development of gravure in Great Britain and the
development of the Anglo Engraving Company was the call-in of gold coins in
1915. The bank-notes which were first issued to replace gold coins were
printed by letterpress. They had denominations of £1 and ten shillings, and
were subjected to large-scale counterfeiting. A commission formed by the
Bank of England, composed of the most important printing experts, concluded
that to produce a bank-note successfully it was necessary to combine during
the production of the printing as many different printing processes as possible.
After extensive experimentation the notes were printed on one side in gravure
and in an offset and letterpress combination on the reverse. The printing was
done by Messrs Waterlow Brothers & Layton. The Anglo Engraving Company
was asked to supply the installation and to instruct the personnel of Waterlow.
Very suddenly the Anglo Engraving Company became the leading firm in
gravure in England technologically and also financially.

Shortly before the outbreak of the war the first perfecting gravure machine
built by Messrs John Wood was installed at the Anglo Engraving Company,
but because of the lack of experience with such machines caused enormous
problems, in particular with the drying of the first printing during the short
travel of the web before it reached the perfecting unit. After the war the firm
took over its competitor Andre & Sleigh where gravure prints were produced
on an Albert sheet-fed 'Walküre' machine, and were marketed under the trade
name 'Busheygrams'.[134] This combination very soon led to the formation of

the Sun Engraving Company gravure department, which grew to world-wide fame under the direction of David Greenhill.

The first illustrated magazine in England, the *Illustrated London News*, founded in 1842, was also the first magazine which supplied regularly to their subscribers heliogravure art prints and special supplementary gifts. It was therefore only natural that the *Illustrated London News* closely observed the development of the modern illustration processes. After the appearance of the 1910 Easter number of the *Freiburger Zeitung* in Mertens gravure, extensive investigations were carried out in Germany. During the trips the executives not only came into contact with Mertens and his group, but also with the Rotogravur in Berlin and their friends in Siegburg. The understanding of technical trends by the managing director Bruce (later Sir Bruce) Ingram and his technical manager Ernest H. Rudd must be specially mentioned, because they realized that the real continuous tone method used in Siegburg would soon replace the Mertens method and that it would be essential for the economic success of a magazine produced in gravure that text and pictures should be printed simultaneously. Still more surprising was the commercial care which they took in stipulating in the contract for the supply of the rotogravure licence that they should be appointed representatives of the Rotogravur Company in England. From the correspondence which was kept in the archives of the *Illustrated London News*[135] and is now in the Science Museum in South Kensington, one can understand that Rudd was very skilful for a long period in preventing serious competition in Great Britain in the gravure production of magazines.

The very unbusiness-like and sometimes rude phrasing of the offers made by Rotogravur for machinery and the even more objectionable methods of negotiating by the German suppliers, which Rudd did nothing to alleviate or adapt to English usage, were probably the main reason why for so long no large gravure reel-fed machinery was sold in Great Britain, with the exception of the machine for the *Illustrated London News*.

Dr Mertens was represented in London by Charles Bell and from his activities a large number of enquiries for gravure installations for the production of magazines were forthcoming from many interested English printing houses.

Before the Tiefdruck Syndikat was founded in 1913 Bell succeeded in selling a small perfector press built in Mulhouse[136] to Butler & Tanner in Frome, Somerset. Another small machine[137] built in Mulhouse was installed in the demonstration room of Bell's firm British Rotary Intaglio Limited. This firm produced small editions of art reproductions from time to time. Bell had undertaken to sell the Mertens process with machines built in Mulhouse. Butler & Tanner installed the press to print illustrations for a small twenty-

four-page magazine,[138] so far produced on a two-colour reel-fed letterpress machine. The intention was to continue to print the text in letterpress on this machine, coupled with the gravure unit for the printing of the illustrations. Up to the beginning of the war in 1914 it was not found possible to run the letterpress and gravure machine in register, and by the end of 1914 further experiments stopped, in the belief that it was impossible to succeed.[139]

The Butler & Tanner machine was sold to the Amalgamated Press in London in 1919.[140] This firm had bought a small perfector press from Charles Bell in 1915, but this press was not a Mertens machine but was built by Mather & Platt in Manchester to the detailed instructions of Charles Bell. On this machine Bell had produced picture postcards and other small products of a similar nature (Fig.67). It is reported that early in 1912 Bell had produced on this machine a section for the periodical issued by the Royal Automobile Club in London using a rather objectionable red printing ink.[141] The machine

67. Gravure perfector reel-fed machine made by Mather & Platt in 1915. From the firm's catalogue of 1915. Collection OML.

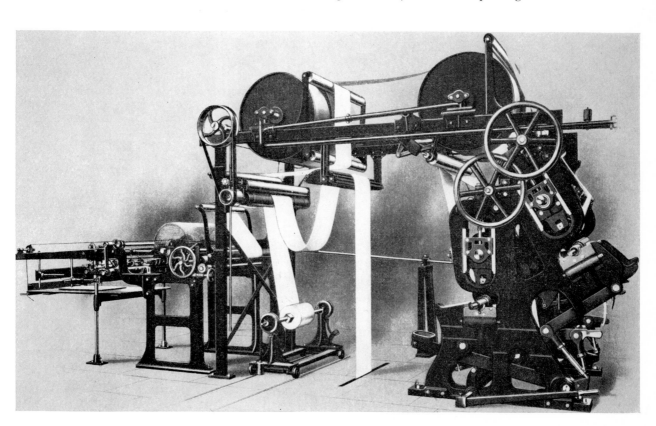

was a small perfector press with sheet delivery. After its installation in the works of Amalgamated Press it was more than five months before it was able to print successfully. The sales contract stipulated that the machine would be capable of printing 3000 prints per hour in the same quality as could be seen every week in the *Illustrated London News*. Everybody was extremely surprised when after a few months Amalgamated Press succeeded in producing on this press 12000 prints per hour. In December 1913 Amalgamated Press had ordered a large gravure press from Tiefdruck Syndikat,[142] but delivery of this machine did not materialize on account of the outbreak of the war. As a substitute for this machine, Amalgamated Press bought first of all the small machine from Bell and ordered in April 1915 a large press from Hoe & Co. in New York. This press was shipped from New York by the middle of November.[143]

The Johannisberg reel-fed press used for the printing of the *Illustrated London News* was delivered in April 1912, and in October 1912, approximately at the same time that the first number of *Der Weltspiegel* appeared from Rudolf Mosse in Berlin, the first eight-page gravure supplement of the *Illustrated London News* was produced successfully using the Siegburg process.[144] An impressive special supplement of the *Illustrated London News* appeared on 8 February 1913, giving a detailed description of the gravure methods and containing pictures of the machine and also descriptions and pictures of a sheet-fed Kempe-Blecher press, which was used to a certain extent for the production of picture supplements for the *Illustrated London News* before total production in gravure could start.[145] All Rudd did for the Tiefdruck Syndikat was to sell a number of Kempe-Blecher sheet-fed presses. By the end of 1913 serious problems arose between the Tiefdruck Syndikat and the *Illustrated London News*, but Rudd personally maintained the full confidence of the supplier. The Syndikat went so far as to offer secretly to Rudd, without the knowledge of his firm, a personal interest in the Tiefdruck Syndikat. However the firm of *Illustrated London News* was apparently not bound by exclusive dealings with the Tiefdruck Syndikat, because they soon installed next to the Johannisberg press another large perfecting gravure press with sheet delivery, made by Pickup & Knowles in Manchester.[146]

By the end of 1912 the *Southend Standard* newspaper displayed great interest in the possibilities of photogravure. The owners, Henry H. and John H. Burrows, travelled extensively in Germany and also visited the *Hamburger Fremdenblatt*. They negotiated for a licence with the Rotogravur Company in Berlin, but the negotiations were abruptly ended by a short letter in January 1913.[147] The brothers Burrows had formed the opinion that the German gravure group did not own any valid patents in the gravure process, and came

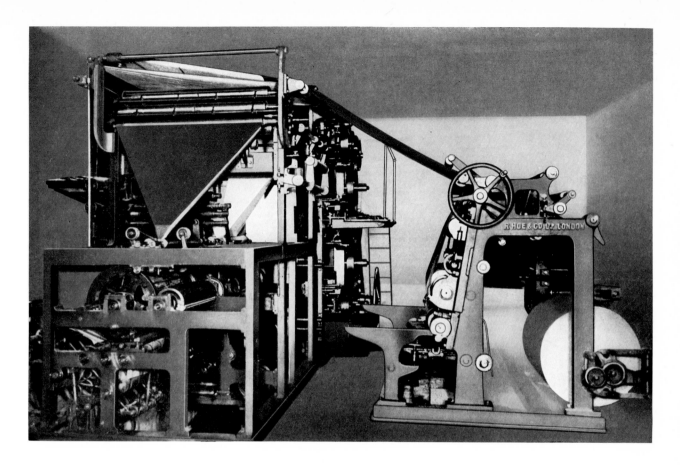

68. The first gravure unit made by
R. Hoe & Co. Ltd, London, attached to the
Foster newspaper press in the works of the
Southend Standard, 1913.
Photo supplied by the *Southend Standard*.

to the conclusion that anybody could freely use gravure printing presses. Mr
William Gamble, director of the largest supplier of graphic arts material,
A. W. Penrose & Co., and in particular his gravure specialist, Mr A. K. Tallent,
supported these conclusions.[148] For several years Messrs Penrose had been
interested in problems of gravure printing. They had developed a method for
cylinder production and also built a small sheet-fed press, which they tried
to market under the trade name 'Velogravure'.[149] Here was an opportunity
to enter the reel-fed gravure machine market. The *Southend Standard* ordered
a single-unit gravure rotary machine from R. Hoe & Co. in London[150]
through Penrose who undertook to produce the first cylinders and to instruct
the personnel at *Southend Standard*.[151] The first edition appeared on
18 December 1913 and the cylinder for this run was produced at Penrose. The

Hoe gravure unit was coupled with a Foster newspaper rotary (Fig.68). During the run of this first edition it was found that the circumference of the gravure cylinder was not exactly the same as the cut-off of the letterpress machine. The consequence was that during the run the gravure picture slowly wandered over the whole length of the newspaper page, and it was necessary to print a very large number of papers and to select by hand all those copies in which the picture fell into the space reserved for it.[152] This difficulty, which was never mentioned by Dr Mertens, was soon overcome. Nevertheless, several months elapsed before the second edition of the *Southend Standard* with gravure illustrations appeared in February 1914. Beginning on 2 April 1914, the paper regularly carried gravure illustrations. In May 1914 the firm succeeded in simultaneous printing of pictures and their captions. It was remarkable that the captions were printed without the gravure screen. This was done on account of the somewhat unclear patent situation. Alerted by the previous negotiations, the Tiefdruck Syndikat watched the developments in Southend with suspicion. Immediately after the appearance of the first gravure illustrations in the paper they served a writ claiming patent infringement. Because of the beginning of the war the case did not come to court.[153] Until 1936 the *Southend Standard* appeared regularly with gravure illustrations. In the following years the gravure unit was used only sporadically and was finally scrapped in 1954 (Fig.69). During the many years this press was used in Southend considerable modifications were made, the most noticeable of which was the replacement of the felt blanket impression arrangement by a rubber impression roller and the introduction of a heated drying drum. During these years the Foster press was replaced by a more modern Goss machine.

Another printing firm of which today nothing is heard in the field of gravure was Taylor, Garnett, Evans & Co. in Manchester, who produced photogravure prints even earlier than 1912. At the International Exhibition for Bookprinting and Graphics, held in Leipzig in 1914, this firm exhibited a catalogue printed before 1912[154] which was illustrated with tipped-in gravure illustrations. The catalogue praised the 'Mezzoprint' process as the newest development after ten years' research and development work.[155] Also the printing press used for the production of these gravure prints was exhibited in Leipzig. It seems that this was a small sheet-fed machine.[156] The precise development and use of gravure in this firm have so far not been established, despite the fact that the firm is still in existence today.

The agents of Schnellpressenfabrik Albert in Frankenthal, Soldan & Co., demonstrated a 'Radiotint' gravure press in London in 1912. The 'Radiotint' press was the machine which in Germany was known under the trade name 'Walküre'. The demonstrations were attended by Mr H. M. Cartwright,[157] who

was at the time an assistant at the London School of Printing, and Mr W. G. Meredith.[158] Messrs Clarke & Sherwell in Northampton, who were the employers of Mr Meredith, ordered from Albert two 'Palatia' sheet-fed gravure No.1 machines in 1913. Mr Meredith, accompanied by Soldan, stayed for several weeks in Frankenthal in 1913[159] to learn the use of the 'Palatia' press and to see how the cylinders for this machine were made. These two presses were installed in the works of Clarke & Sherwell by Hans Schulte (see page 105) towards the end of 1913. Also here, as in most early gravure houses, enormous difficulties had to be overcome. The main problem was the damage to the gravure cylinder caused by hard particles in the gravure ink. Mr Meredith

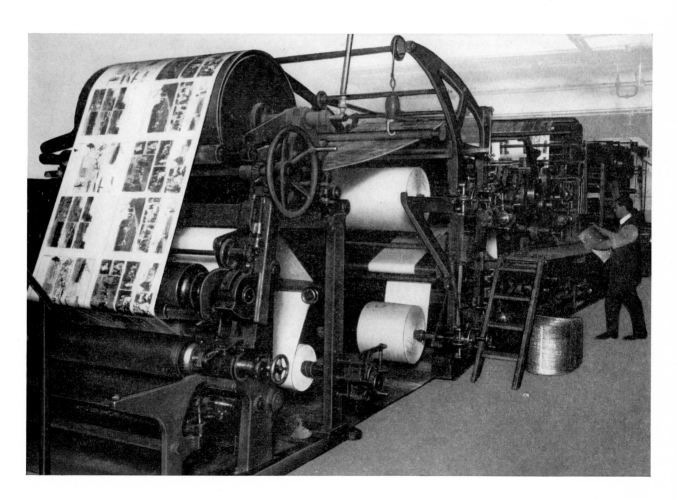

69. The *Southend Standard* hybrid press arrangement in 1936. The original Hoe gravure press modified by the addition of a rubber impression roller and the drying drum. The newspaper part was made by Goss, Preston.
Photo supplied by *Southend Standard*.

70. Palatia No.1 machine (press No.12710) from Albert & Cie delivered to Clarke & Sherwell in Northampton in 1914. Photo taken in 1956 and supplied by Mr Cecil P. Clarke.

reports that an early order consisting of 250 000 advertising sheets to be printed four up on newsprint[160] required him to etch thirty cylinders.[161] Clarke & Sherwell are still in business today and one of the two first 'Palatia' machines was still in use only a few years ago (Fig.70).[162]

Developments in the USA

Hermann Horn and Harry Lythgoe, an engraver working in a London wallpaper printing house, helped Theodor Reich with his first gravure experiments in his flat in the years 1903 and 1904. Hermann Horn sent some of the first successful prints to a number of art dealers in America, whose addresses he selected arbitrarily out of a directory.[163] One of these prints reached a portrait photographer called Gutekunst in Philadelphia, who showed this print to a picture dealer and frame-maker Edward A. Walz.[164] Walz embarked on a buying trip to Europe together with his brother-in-law Anton Heiser early in 1904. He came to visit Horn and Lythgoe in London and had a gravure print made of a portrait of himself.[165] In the autumn of the same year Walz again came to London and made a contract with Horn and Lythgoe to move to Philadelphia with all their equipment, taking with them a small gravure two-colour printing press built by John Wood.[166] They were soon installed in the house of a printer called Jacobs at 125 North 51st Street, on the sixth floor of this building.[167] They had power available up to four horsepower created by a steam engine installed in the cellar of the building supplying power to the tenants by a rather complicated mechanical transmission. During the period Horn and Lythgoe installed the equipment and produced the first American gravure print 'Dante meets Beatrice', a reproduction of a painting by Rosetti,[168] the American Photogravure Company was established with Anton Heiser as President. In 1906 the firm was in financial difficulties and a new company, Photogravure Company of America Limited, was founded and took over the equipment of the now defunct first group. Again Heiser was made President of the new firm, Horn, General Manager and Lythgoe, Cashier. In 1910 Horn returned to Germany and was employed in Augsburg by MAN. Very little is known regarding the activities and the fate of the Photogravure Company of America. In the Philadelphia trade directory the firm is named in all volumes up to the year 1915[169] under the title Photogravure Company of America Ltd (Harry Lythgoe, Anton G. Heiser, Edward Walz, Geo. C. & P. Newman), 125 North 51st Street.

The activities of Charles William Saalburg[170] are of greater importance than the activities of these first American photogravure installations, whose technical originator was Theodor Reich. Unfortunately Saalburg was one of those gentlemen who, despite the fact that they had considerable and valuable influence on the development of gravure through their employment, always tried to claim that they had done everything single-handed. Saalburg's claims which were made to Edward Epstean, who planned a biography of Saalburg which unfortunately never materialized, are to be treated with great scepticism.[171] In the Saalburg complex Ernest Champion Bradshaw played an important part. Bradshaw, according to his own information, claims to have worked for many years in the Rembrandt Company in Lancaster, before he emigrated to America in 1903. According to information from several early employees of the Rembrandt Company, who were still living when the investigations for this history of gravure were made by the author,[172] Bradshaw was running a small photographic shop and studio in Lancaster about 1900 and was from time to time asked to assist Rembrandt's photographer Thompson in his work. This statement is supported by the fact that Bradshaw left Lancaster in 1902 to accept a position in the Swan Electric Engraving Company in London, which also played a part in the early history of photogravure.[173] William Gamble, director of the largest English supplier of printing equipment and sundries, was at the time editor of Penrose's Pictorial Annual *The Process Yearbook* (later to become *The Penrose Annual*). He and the editor of the influential trade periodical *Process Engraver's Monthly*, H. Snowden-Ward, were very well informed and were well aware of the trends and developments in the printing industry of England, many of them secret. In 1911 Gamble was a witness in a patent suit in London, where he stated[174] that Bradshaw had tried to obtain a position at Penrose in 1903 and that he, Gamble, had been instrumental in getting him a position with the London printers Colls, where he was introduced to the secrets of dust-grain heliogravure. Shortly afterwards Bradshaw had experimented with the application of his knowledge to cylinder production. It is very probable that this information is correct, because Bradshaw had his shop in close proximity to the Rembrandt Company in Lancaster for a period of eight or nine years, and could add to any information he acquired during this time by his connexion with Swan and Colls. Gamble was responsible for bringing Bradshaw and Saalburg together, and Bradshaw succeeded in convincing Saalburg that he knew all about the so far secret gravure process and was in a position to introduce it wherever necessary. This was the reason why Saalburg induced him to go to America. Saalburg had close connexions with Mr Don C. Seitz, the General Manager of the *New York World*. The three men founded the Van Dyck Gravure Company in October 1903, but

it took a very long time before this company was in a position to produce prints. Saalburg himself has stated that the Van Dyck Company began to market a quality gravure print during the year 1908. By 1906 it became pretty obvious that neither Bradshaw's knowledge, nor the printing press built by Messrs Campbell according to Bradshaw's design, nor the other equipment, was in any way satisfactory, and these matters led to the dismissal of Bradshaw.[175] Saalburg succeeded in obtaining a large number of American, English and German patents covering the methods evolved in this collaboration. It is remarkable, however, that the December 1908 number of the American trade paper *Inland Printer* could carry a three-colour gravure print made by Saalburg. Bradshaw changed his employment by joining the Rotary Photogravure Company which was founded in 1905. According to information from Mr Frederick D. Murphy, President of the Art Gravure Company in New York,[176] his father-in-law, Frederick Sugdon, visited England in 1900 accompanied by Richard Barlow, a representative of the Pacific Mill in Lawrence, Massachusetts, where they saw Rembrandt prints and learned that these were produced on rotary presses using doctor blades. Saalburg reports that he had great difficulty in grinding the blades for the machines made by Campbell and that Sugdon, who was works manager of the Passaic Textile Printing Works, instructed him how to do it. Out of a collaboration between Sugdon and an ink chemist, Jacques Wolf, the Rotary Photogravure Company of Passaic[177] was founded with Mr Bradshaw as collaborator. The third effort to introduce gravure into America was made by Frederick T. Corkett, who had acquired a licence for the mezzotint process from Bruckmann in Munich and who had learned details of the working procedure by a stay of several months with this company.[178] Corkett demonstrated in England to a small circle of printing experts a small gravure machine and then travelled to America with the prints to found the Corkett Intaglio Company, Art Printers in New York, apparently in the hope of selling prints produced in England. S. H. Horgan,[179] one of the co-inventors of the halftone process, to whom Corkett was introduced with a letter from Snowden-Ward, brought Corkett to see Joseph P. Knapp. Knapp was manager of the very large American Lithographic Company and was so interested in the new process that he engaged Corkett on the spot and acquired his small gravure press built by John Wood, with the aim of introducing the production of mezzotint prints by his company. Mr Murphy[180] reports that Corkett was paid a fee of $50000. The gravure department expanded very rapidly and was soon transformed into a separate company, Alco Gravure Company, a firm which even today plays an important role in the gravure industry of America. Further presses acquired by Alco were built by Edward F. Harrington & Sons in Philadelphia.[181] The business concentrated, as was natural

from the organization of the founder firm and the previous experience of Corkett, on the manufacture of art reproductions, postcards, etc. In 1912, after the progress which gravure processes had made during previous years, particularly in the field of magazine and newspaper production, Corkett's experience was insufficient and he returned to England. He was replaced as works manager in the Alco company by Frederick D. Murphy, a position he held till 1919 when he left to start the Art Gravure Corporation in New York, another large firm in the gravure field which still exists today.[182]

The first success with the introduction of the Mertens process in America was the acquisition of the process and a machine built in Mulhouse by the National Cash Register Company, of Dayton, Ohio.[183] The N.C.R. issued a weekly housemagazine broadside for its employees and representatives with detailed information on the products and developments of the cash registers. During a trip to Europe the founder of the N.C.R., John H. Patterson, saw the Mertens process and placed an order for a perfector machine in Mulhouse, which was delivered to Dayton in October 1911.[184] Patterson engaged at the same time two Mertens experts, one of whom was the etcher Guido von Webern, who was concerned with the development of gravure in the early stages of the installation at Loewy in Vienna (see page 61).

During a trip in 1912, Julius Hermann, of Sackett & Wilhelms in New York, saw at Mosse in Berlin a Johannisberg perfector gravure machine and ordered a similar press from Siegburg. The Internationale Tiefdruck GmbH in Berlin persuaded Hermann to found the American Rotogravure Company, also to take over the representation of the Internationale Tiefdruck GmbH, and was later one of the co-founders of the Tiefdruck Syndikat. This was the start of the subsequent rapid introduction of the Siegburg process by the Curtis Publishing Company in Philadelphia in 1912, followed by the *Boston Herald* and the *Chicago Tribune*. In 1914 the process was introduced at Grips Limited in Toronto, *The Cleveland Plain Dealer*, The Regensteiner Color Type Company in Chicago and the *New York Times*.[185]

The first edition of the *New York Times* carrying a gravure supplement appeared on 5 April 1914 and from 26 July of the same year this became a regular weekly appearance.[186] This pioneer action of the publisher of the *New York Times*, Adolph Ochs, caused a sensation in America similar to the appearance in Europe of the Easter Number of the *Freiburger Zeitung* under Mr Max Ortmann in 1910.

In the same way as the Schnellpressenfabrik Albert in Europe worked independently from the circle round Siegburg and sold gravure machines independently and without any connexion with the Tiefdruck Syndikat, the old-established printing press manufacturers R. Hoe & Co. Inc. in New York

kept themselves free from such ties. The first reel-fed photogravure machine built by Hoe was a single unit press which was combined with a Hoe newspaper press and was installed in September 1912 at the *New York Sun*.[187] Up to the outbreak of the war in 1914 it appears that the Tiefdruck Syndikat had a certain success in defending its monopoly position in America as well, because the next Hoe gravure machines, which were all perfecting machines, were only delivered in 1916 to American firms, *The Cleveland Plain Dealer*, the *Times Mirror* in Los Angeles and the *New York American*.[188] In 1915 ten American magazine printers and eight newspapers were running gravure departments printing broadsheet gravure supplements which appeared weekly. Not until 1925 were the developments at the *New York Evening Post* sufficiently far advanced to enable the newspaper to come out with a daily gravure supplement.[189]

The development in other countries

Reliable information regarding the beginning of gravure can only be obtained by extensive and time-consuming investigation in the places involved, by incidental information, research in old trade papers and by occasional hints obtained from people who are interested in the history of printing.

Developments in England, Germany and to a certain extent also in France were ascertained by personal comparative studies of archives during extensive visits to the many places concerned. The author's personal appearance in the towns, factories and printing houses made it possible to induce some of the old hands in the gravure business to talk freely. From the records of these discussions valuable information appeared, together with a very large number of details which were obviously based on wishful thinking and unreliable hearsay information. Unfortunately, it was not possible to pursue a similar systematic investigation in other countries. The following details are therefore based on information received by correspondence not always with those who were directly concerned. It is more than likely that in other countries than those dealt with in greater detail development work had also been going on, about which nothing has become known so far. The author of this book hopes that its appearance may lead to further information by interested readers, who have access to other sources and reliable information to supplement this basic gravure history for the benefit of the history of technology.

The Société Alsacienne de Constructions Mécaniques in Mulhouse in the Alsace provided a list of gravure presses which they have supplied from 1909 onwards. From this information it is obvious that Denmark deserves credit as the first country where extensive gravure experiments were made outside England, Germany and America. Mr Carl Aller in Valby had contact with Dr Mertens as early as 1907.[190] Further details can be found on page 75.

The next Scandinavian gravure installation was Egmont H. Petersen in Copenhagen, who installed in 1914 two perfector presses fitted with sheet delivery made by König & Bauer in Würzburg.[191] In 1918 this machine was sold to Nordisk Rotogravyr in Stockholm.[192]

The first gravure plant in Sweden was apparently Ehrnfried Nyberg Boktrykare in Stockholm[193] who in November 1913 received from Mulhouse a perfecting press with König & Bauer sheet delivery.

At the end of 1910, R. Baschet, the proprietor of *L'Illustration,* began to produce gravure prints using a Mulhouse perfecting press fitted with a König & Bauer folder.[194] In 1913 we find Crété in Corbeil[195] (Fig.71) and Deplanche Falk & Cie in Montrouge[196] working with perfecting gravure presses fitted with deliveries made by Marinoni. In the same year *Petit Parisien* in Paris[197] installed a perfector press and *L'Eclair de Montpellier*[197] two single unit gravure presses which were coupled in hybrid fashion with Marinoni newspaper presses used in these printing houses. A little earlier, by the end of 1912, the representative of the Internationale Tiefdruck GmbH formed La Photogravure Rotative in Paris, which firm a little later became a member of the Tiefdruck Syndikat.[199]

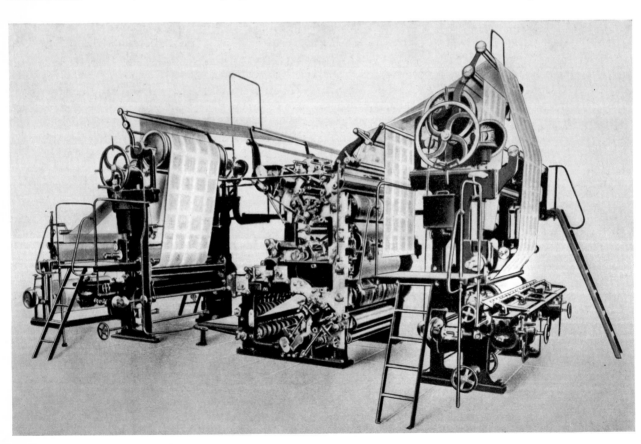

71. SACM machine No.28 delivered in March 1913 to Messrs Crété in Corbeil. Hybrid arrangement with a Marinoni letterpress rotary for the production of *Lectures pour tous.* From a catalogue of La Photogravure Rotative, Paris, of 1914. Collection OML.

The development in Russia was well prepared with an extensive use of dust-grain heliogravure. Therefore it is not surprising that in January 1911 two perfector gravure machines were supplied to the newspaper *Birschewyja Wjedomosti*, owned by Mr S. M. Propper in St Petersburg.[200] The machines were coupled, following the example in Freiburg, to newspaper presses built by Vogtländer Maschinenfabrik in Plauen and the installation was in full production in early summer 1911. By the end of 1913 three further perfecting machines had been delivered to the same newspaper plant,[201] but only one of these was coupled with a newspaper press made by Plauen; the other two were fitted with König & Bauer sheet deliveries. It seems that at this time the installation of Mr Propper in St Petersburg must have been the largest gravure installation, employing ten gravure units, whereas the largest installation in Germany about the same time, Rudolf Mosse in Berlin, used only eight gravure units (Fig. 72).[202]

72. The gravure press room at Rudolf Mosse, Berlin, with four reel-fed gravure perfector presses from SACM.
From 'Festschrift zur Feier des 50 jährigen Bestehens der Annoncen-Expedition Rudolf Mosse zum 1. Januar 1917.'

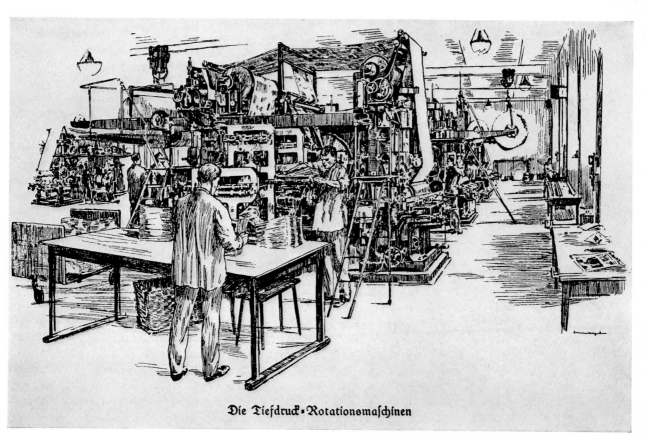

Die Tiefdruck-Rotationsmaschinen

In January 1914 the publishing house Kopeika in St Petersburg installed a Mulhouse press with three units and a MAN sheet delivery[203] and in March of the same year J. D. Sytin a similar press.[204] In March 1914 a further machine was delivered to Constantin de Nesluchowsky also in St Petersburg.[205] Wilhelm Bretag, who later on for many years was the editor of the German trade paper *Deutscher Drucker*[206] writes: 'In 1907 I entered the largest supplier to the graphic arts, Johs. Flohr in Moscow ... This firm was the representative of MAN ... and also took over the representation of the Tiefdruck Syndikat in 1912 ... The machine was built in Mulhouse but the folder and sheet deliveries were made by MAN in Augsburg. The press was intended to produce a weekly magazine *Iskry (The Sparks)* ... The machine started to work approximately six weeks prior to the outbreak of the First World War. A trial number of *Iskry* was produced ... Next to these reel-fed gravure machines five or six Kempe-Blecher sheet fed plate gravure presses were installed in Moscow prior to the war. Two of these came to J. D. Systin, a further two were in the printing house of A. A. Levenson and one or two in ... a printing house, the owners of which were two Germans, Wilhelm and Hermann Welfers ... The last firm had bought from Bruckmann in Munich a licence for the Mezzotinto process and had originally started to produce gravure prints on a modified direct stone lithographic press ... All these machines produced predominantly art reproductions and to a certain extent also picture postcards and pictures to be tipped into books ...'

Messrs Ringier of Zofingen in Switzerland claim to have been the first gravure printers in Switzerland, because they installed early in 1914 a reel-fed rotogravure machine made by Albert & Cie in Frankenthal. The machine was exhibited at the Schweizerische Landesausstellung (Swiss National Exhibition) which was held in Berne from 15 May to 15 October 1914. The official guide to the Exhibition states:[207] '... The department shows the state of modern magazine production and one can see ... a reel-fed gravure machine which is used for the production of the weekly *Schweizer Illustrierte.*'

A search in the archives of the *Schweizer Illustrierte* shows that the first number containing an eight-page gravure supplement was dated 6 June 1914. During the period from 15 August to 28 November all numbers of this magazine were produced entirely by letterpress, but beginning with the next issue a few gravure-printed pages can be found. Beginning with the number of 6 March 1915 the *Schweizer Illustrierte Zeitung* was produced completely and regularly in photogravure.[208] The Albert gravure press, which was exhibited in Berne and which was used to print these first numbers of the Swiss magazine in gravure, was preserved in the print room of the Ringier organization up to a few years ago.

In September 1912 the Elsässische Maschinenfabrik supplied to Société des Arts Graphiques, SADAG, Geneva a perfector gravure press fitted with a König & Bauer sheet delivery.[209] Early in 1913 the director of SADAG, Mr Jean Luginbuhl, made a trip to Munich to be instructed in the secrets of the gravure process.[210] In the same year Luginbuhl established in Geneva La Rotogravure, the nucleus from which the important gravure house in France, E. Desfosses-Neogravure, was developed under the direction of Jean Luginbuhl.

In 1913 in Spain *La Tribuna* in Barcelona,[211] in Belgium Bordet von Drosselaere in Ghent[212] and in Vienna the Östereichische Zeitungsdruckerei AG Karl Groak[213] started to produce gravure on single unit presses built in Mulhouse, and in the same year Drukarnia i Ksiegarnia in Posen started with a perfector machine.[214]

In 1914 Mulhouse supplied presses to Athenaeum in Budapest.[215] The first reel-fed rotogravure machines built by Albert & Cie in Frankenthal were the presses already mentioned for Ringier in Zofingen and a further machine which was delivered to N. V. Druckerij de Spaarnestad in Haarlem in 1915, which was designed to produce twenty-four page magazines.[216]

A few months earlier Nederlandsche Rotogravure Maatschappij of Leiden had installed a Johannisberg press of a similar design to the machine for the *Illustrated London News*.[217] The general manager of the Nederlandsche Rotogravure Maatschappij, Mr L. Lewisson, was a strong force in the further development of gravure after the war and was one of the pioneers of colour gravure printing. By a very close collaboration between Lewisson and Dr Nefgen, Johannisberg succeeded in bringing out a sheet-fed gravure press under the trade name 'Liti' in competition with the 'Palatia' machines built by Albert. Such a sheet-fed 'Liti' machine was used in Leiden during the First World War for large-scale experimentation with colour printing, which resulted in the fact that towards the end of the war the Nederlandsche Rotogravure Maatschappij could successfully sell very high-class colour gravure prints. As far as can be ascertained at this time, there were in about 1920 more than 100 firms all over the world using gravure in the modern sense. The largest installation had up to twelve printing units discounting any sheet-fed machinery.

If one considers that the development of gravure began to interest widening printers' circles in 1910, and that the First World War lasted from 1914 to early 1919 very severely hampering the technical development, then one can only speak of the triumphant progress of gravure.

References

1 *Biography: Hofrat Dr Joseph Maria Eder, 1855–1944.*
Sein Leben, by F. Dworschak; *Sein Werk*, by O. Krumpel.
Graphische Lehr- und Versuchsanstalt (Vienna 1955).

2 Josef Maria Eder. *Ausführliches Handbuch der Photographie.*
16 parts.
Published by Wilhelm Knapp (Halle 1919–32).

3 J. S. Mertle, FRPS, FPSA, SPSE. Evolution of Rotogravure.
Gravure Magazine. In 20 parts. Garden City N.Y.
(November 1955–June 1957.)

4 John Jackson. *A Treatise on Wood Engraving.*
Charles Knight & Co. (Ludgate Street, London 1839).

5 Konrad F. Bauer. *Aventur und Kunst*. Privately printed.
Bauersche Giesserei (Frankfurt am Main 1940).

6 Alexander Braun. *Der Tiefdruck, seine Verfahren und Maschinen.*
Polygraph Verlag (Frankfurt am Main 1952).

7 Anon. *Sculptura-Historico-Technica or the History and Art of Engraving.*
S. Harding on the pavement in St Martin's Lane, London 1747.

8 The oldest reproduction of this print is found in *Essai sur Nielles par Duchesne Aîné* (Paris 1826). See also C. F. von Rumohr, *Untersuchung der Gründe für die Annahme, dass Maso Finiguerra Erfinder des Handgriffes sei, gestochene Metallplatten auf genetztes Papier abzudrucken.* (Investigations into the reasons for the assumption that Maso Finiguerra invented the manipulation to print engraved metal plates on to dampened paper) (Leipzig 1841).
An article in the German trade paper *Gold und Silber*, Stuttgart, reports that the first mention of the fact or fiction is by Georgio Vasari in *Le Vite*, Florence, 1568.

9 Detailed information on LeBlon can be found in Jacob von Falk, *Farbige Kupferstiche, Photographische Korrespondenz,* page 70 ff. Vienna 1892, and in H. W. Singer, LeBlon and his 3 colour prints, *The Studio* (1903) page 261. See also Dr G. K. Nagler. *Neues allgemeines Künstler-Lexikon* (Munich 1835).

10 British Patent No.423 of 5 February 1719. LeBlon's Patent.
A new Method of multiplying Pictures and Drafts by a natural Coloris with Impression.

11 Bilingual publication. *L'Harmonie du Coloris dans la Peinture, Coloritto or the Harmony of Colouring in Painting* (London 1722). A copy of this first edition with a frontispiece printed in three-colour mezzotint is in the Library of the Victoria and Albert Museum in London. A second edition appeared after LeBlon's death in Paris 1756, edited by A. Gautier de Mondorge.

12 J. M. Eder. *Ausführliches Handbuch der Photographie.*
Volume Heliogravure, page 37.
Wilhelm Knapp (Halle 1922).

13 Stapart. *Die Kunst, mit dem Pinsel zu ätzen* (Nürnberg 1780).

14 *L'Art de Graver au Pinceau. Nouvelle Méthode par M. Stapart* (Paris 1773).

15 British Patent No. 1378 of 12 November 1783. Thomas Bell of Mosney in the County of Lancaster, Copper engraver.
My invention of a new and Peculiar Art or Method of Printing with one Colour or with Various Colours at the same time in Linnens, Lawns, and Cambricks, Cottons, Calicoes, and Muslins, Wollen Cloths, Silks, Silk and Stuffs, Gauzes and any other Species or Kind of Linnen Cloth or Manufactured Goods Whatsoever.

16 British Patent No.1443 of 2 August 1784. Thomas Bell the elder, of Walton in the Dale in the County of Lancaster, Copper engraver. *My invention of A New Peculiar and Improved Art or Method of Printing One, Two, Three, Four, Five or More Colours all at One and the Same Time upon Linnen, Cottons, Calicoes, Muslins, Wollen Cloths, Silks, Stuffs or any other Species of Goods or Articles capable of being printed, by a much cheaper Method than hitherto found out.*

17 W. A. Abrams. *History of Blackburn* (1877), page 22.

18 J. M. Eder. *Geschichte der Photographie*, 2 volumes. Wilhelm Knapp (Halle 1932).

19 Helmut and Alison Gernsheim. *The History of Photography.* Oxford University Press (1955). Second Edition 1969.

20 Joseph-Niécephore Niépce, born 1765 in Chalon-sur-Saone, died 1833 in St Loup de Varenne. In 1813 he started experiments in lithography trying to replace the heavy calciferous stones by metal plates, and tried many light-sensitive substances for the production of lithographic printing plates. In 1822 he discovered the suitability of light-sensitive asphaltum for photographic images. In 1826 (and not 1824 as is stated on the print reproduced in Fig.5, see Eder, *History*, Volume I, page 261 ff.) he produced the first photo-mechanical etching on metal plates using zinc. The few surviving specimens of his experiments and the documents of his life are

kept at the museum in Chalon-sur-Saône, and were placed at the author's disposal by the Director of the museum, M. Louis Armand-Calliat.

21 Mungo Ponton. Born 1801 in Belgren near Edinburgh, died 1880 in Clifton.

22 *New Philosophical Journal* (Edinburgh 1839), page 169.

23 William Henry Fox Talbot. Born 1800 in Melbury, Dorset, died 1877 at Laycock Abbey, the family seat. Detailed biography in Eder, *History*, Volume I, page 432.

24 British Patent No.565 of 29 October 1852.

25 Paul Pretsch, born in Vienna in 1808. He came to London to organize the exhibit of the Vienna State Printing Office at the Exhibition of 1851. Pretsch died in Vienna in 1873.

26 British Patent No.2373 of 9 September 1854.

27 Alphons Louis Poitevin. Born 1819 in Conflans, died there in 1882. He investigated the properties of chrome salts and invented the pigment printing process. British Patents No.2815 and No.2816 of 13 December 1855.

28 British Patent No.875 of 21 April 1858.

29 French Patent No.47008 of 8 October 1860.

30 Dr Eduard Mertens. Born 1860 in Berlin, died 1919 in Freiburg. See Braun (6), page 256.

31 Private communication from J. S. Mertle.

32 *The Lithographer* (7 August 1871), page 7. Godchaux & Co.'s machine for printing copybooks, etc.

33 George Philip. *The Story of the House of Philip during the last 100 years*, George Philip & Son Ltd (London 1934), page 14.

34 French Patent No.34719 of 14 December 1857.

35 British Patent No.503 of 29 February 1864. Joseph Wilson Swan, later Sir Joseph Swan, 1828–1914. After the invention of the Carbon process, Swan investigated the production of line screens for blockmaking. He collaborated in early investigations leading to the invention of photographic dry plates. His most important invention is the incandescent lamp contemporary with the development by Edison. Both inventors combined their rights and lightbulbs are still available in England today with the trademark Ediswan.

36 Prof. Karl Albert. *Karl Klietsch, der Erfinder der Heliogravure und des Rakeltiefdrucks*. Graphische Lehr- und Versuchsanstalt (Vienna 1927).

37 J. S. Mertle. Evolution of Rotogravure. *Gravure Magazine*, Garden City, N.Y. Parts 10, 11, 12 (August to October 1956).

38 Cited by Edward Rouse, Director of the Autotype Company Ltd in London in his paper, *Methoden der Behandlung von Pigmentpapier (Methods of working with pigment paper)* read at the Annual Meeting of the Bundessparte Tiefdruck, Hamburg, July 1956.

39 *Rembrandt Review* (London 1932).

40 *Process Photogram* (London 1897), page 73.

41 Frederick Eugen Ives. Born 1856 in Litchfield, Connecticut, died 1936 in Philadelphia. He was a pioneer in the fields of colour photography, screen manufacture and halftone photography. He also invented the Chromoscope, a viewer for additive colour photography.

42 Thos. Huson. *Photoaquatint and Photogravure*. Dawbarn & Ward Ltd (London 1897).

43 Ernst Rolffs. Born 1859 in Siegfeld, died 1939 in Heidelberg.

44 Theodor Reich. Born 1861 in Vienna, died 1939 in Vienna.

45 *Print and Progress*, Volume 2, page 14.

46 John Wood. 1851–1936 in Ramsbottom near Manchester. He founded a mechanical workshop in 1881 for the production of textile machinery, especially printing presses. The firm still existed in 1970.

47 Karl Albert. The Beginnings of Rotogravure in America. *Penrose's Annual*, Volume 30 (London 1928), page 127.

48 German Patent DRP No.129679 of 15 June 1899. *Rastrierte Tiefdruckwalze (Screened gravure cylinder)*.

49 Private communication by Mr A. H. Lockington to the author during his visit in 1958.

50 Oscar Pustet. 1857–1928 in Vienna. See also *Wiener Tiefdruck* by Franz Gesierich. Staatliche Graphische Lehr- und Versuchsanstalt (Vienna 1946).

51 *New Scientist*, No.259 (London, 2 November 1961).

52 In the picture of the staff of the Rembrandt Company (Fig.23), Edward Hunter sits at the extreme right in the third row not wearing a cap. He was born in Lancaster on 3 June 1880 and died in Winterhaven in Florida on 19 April 1948. He was one of Rembrandt's retouchers. In 1911 he emigrated to America to join the Van Dyck Company and later worked at Crowell-Collier, Standard Gravure and Neogravure. Further details can be found in Mertle, Evolution of Rotogravure. Part 15, *Gravure* (January 1957).

53 In 1955 Mr L. T. A. Robinson was Managing Director of the London gravure plant Samuel Stephen Ltd, Norwood. In 1925 he designed reel-fed gravure presses which printed from thin detachable copper plates. The gaps necessary to fix the plates to the carrier cylinder were slanting in relation to the cylinder axis and were closed by leather strips to enable the doctor blade to ride smoothly over the gap. The presses were still in use in 1970 for the production of long runs of brilliantly coloured children's books in the works of Messrs L. T. A. Robinson in London, a subsidiary of the British Printing Corporation.

54 Storeys of Lancaster still ran a large gravure printing department for the decoration of textile and plastic sheets in 1970, under the management of Mr W. D. F. Fawcett, the grandson of Samuel Fawcett.

55 Hermann Horn. In the early days of Rotary Photogravure. *Print and Progress*, Volume 2, No.14.

56 The first Rembrandt prints in *The Studio* are *The Rhine Daughters* by Charles Robinson in Volume 18, followed by *Colonel Hamilton* by J. J. Sargent in Volume 19, both of 1900. Volumes in the Westminster Public Library, London.

57 The author visited the engineering works of John Wood (Engineers) Ltd in Ramsbottom near Manchester in 1955 and was given access to early order books and other documents dating back to the foundation of the firm in 1881.

58 The machine is illustrated in *Penrose's Annual*, Volume 33 (London 1931), page 134.

59 See Fig.26. Frontispiece of *Penrose's Pictorial Annual*, Volume XI (1905–6).

60 Letters from Mr Hans Vetter to the author (1955–6).

61 See Karl Albert, *Karl Klietsch*, page 30.

62 See Karl Albert, *Karl Klietsch*, page 43. Also Mertle, Evolution of Rotogravure, Part 13. *Gravure* (November 1956).

63 Hermann Horn. In the early days of Rotary Photogravure. *Print and Progress*, Volume 2, No.14.

64 Letters to the author from Oberpostrat Krahwinkel dated 10 January 1956 and subsequent detailed correspondence with the Sachbearbeiter Mr Julius Sesar.

65 Director O. Luttmer of Messrs Brend'amour Simhart confirms this in his letter to the author of 9 February 1956: '. . . *In 1913 or 1914 tenders were requested for the production of postage stamps for the State of Bavaria and we . . . had submitted sample prints . . . For some reason . . . we were not given the order . . . maybe because our installation was thought not to have the required capacity . . .*'

66 Letter to the author from Mr W. D. F. Fawcett of 20 January 1956.

67 F. J. Melville. *British Postage Stamps in the Making*. Revised edition by John Easton. Faber & Faber (London 1949), pages 207 and 208.

68 Franz Gesierich. *Wiener Tiefdruck* (Intaglio). Staatliche Lehr- und Versuchsanstalt (Vienna 1946).

69 A progressive proof of this print is preserved in the Museum of the Royal Photographic Society in London in a folder of prints and documents presented to the Society by Mr A. H. Lockington. The print carries a note from Mr Lockington: 'Colour gravure print which I made in 1912 using a modified lithographic press. Print from flat copper plate using a steel doctor blade.'

70 Wilhelm Gustav Horn, born 1871. 1900 to 1923 employed at Messrs Meisenbach Riffarth & Co. in Berlin-Schöneberg. 1923 to 1937 Chief gravure retoucher at Messrs Rudolf Mosse, Berlin. 1937–9 Gravure retoucher at Belcolor Ltd, Slough. After 1945 at Ganymed Ltd, London. Verbal information to the author 24 January 1956.

71 See Karl Albert, *Karl Klietsch*. Reich was granted a German DRP 237038 dated 12 July 1910 for the design.

72 Autobiographical notes by Ernst Rolffs preserved in the Heimatmuseum in Siegburg.

73 Notes for a biography of Rolffs by Gerhard Koch. Heimatmuseum in Siegburg.

74 Eder, *Heliogravüre und Rotationstiefdruck*, Wilhelm Knapp (Halle 1922), page 93.

75 The Controller at the German Patent Office did not have the original paper: *Photographisches Verfahren zur Herstellung von Druckwalzen für den Stoffdruck* (*Photographic process for the production of printing rollers for textile printing*) by Adolph Brandweiner. *Photographische Korrespondenz*, pages 1–8 (Vienna 1892). He refers to a detailed but incomplete abstract of the paper in Wilhelm Toifel, *Handbuch der Chemigraphie*, A. Hartleben Verlag (Vienna 1896), page 194.

76 Correspondence between Rolffs and his patent agents A. Kühn & R. Dreiser, Berlin N.W., Louisenstrasse 31a Heimatmuseum Siegburg.

77 Letter from Rolffs to Dr Mertens dated 30 December 1913 reproduced in *Die historische Entwicklung des Rotationstiefdrucks* (The history of the rotary gravure process) by Ernst Rolffs, which is a polemic pamphlet addressed to the *Kölnische Zeitung* in July 1928.

78 In the copybook of Rolffs kept in the Heimatmuseum in Siegburg.

79 Dr Mertens' German patent DRP 125917 of 11 February 1900 (*Method for coating of cylinders with layer forming liquids*).

80 German patent DRP 114924 taken out in the name of Dr Maemecke who was one of Rolffs' patent agents dated 29 September 1899 (*Process for the even coating of cylinders with light-sensitive layers*).

81 In the Heimatmuseum in Siegburg.

82 See Eder, *Heliogravure*, page 98.

83 German patents Nos.161635, 164019, 166499, 169748, 173215, 176319, 178838 and many others under the name of Dr E. Mertens.

84 See Eder, *Heliogravure*, page 99.

85 See Eder, *Heliogravure*, page 98.

86 Copy in the Heimatmuseum in Siegburg.

87 Copy in the archive Gerhard Koch kept at the Heimatmuseum Siegburg.

88 Unfinished manuscript *Ernst Rolffs, Erfinder des maschinellen Kupfertiefdrucks* (*Ernst Rolffs, Inventor of machine printed gravure*) in the papers of Gerhard Koch in the Heimatmuseum in Siegburg.

89 German patent DRP 169748.

90 Original letters in the papers of the late Mr Claes Aller, The Aller Press Ltd, Valby, Copenhagen.

91 Letter from Mr Claes Aller to the author dated 26 June 1956.

92 See Eder, *Heliogravure*, pages 105–6.

93 The number can be found as supplement to *Klimsch Jahrbuch für das graphische Gewerbe*, Volume 11, Klimsch & Co. (Frankfurt 1911).

94 The machine is a hydraulic press of suitable design.

95 *Freiburger Zeitung* (Easter 1910, May and August 1910); *Frankfurter Zeitung* (19 February 1911); *Hamburger Fremdenblatt* (19 March 1911, etc.)

96 Copy of the letter to Professor Miethe dated 2 March 1902 in the Heimatmuseum in Siegburg, saying: '. . . *referring to your kind agreement to the training in three colour printing . . . I ask you if it will be convenient if my photographer comes to you during the next week . . .*'

97 See Carl Blecher, *Lehrbuch der Reproduktionstechnik* (*Handbook of process work*), Verlag Wilhelm Knapp (Halle 1908), page 129 ff.

98 German Patent DRP 169748. Dr E. Mertens, *Verfahren zum Drucken von Text allein oder in Verbindung mit Illustrationen* (*Method for printing text matter alone or in conjunction with illustrations*) dated 10 April 1904.

99 Letter from Rotogravur in Berlin to Mr E. H. Rudd of *Illustrated London News* dated 14 December 1912, preserved in Sir Bruce Ingram's paper at the Science Museum in London.

100 From Tiefdruck by Hermann Kempe published in *Der Stereotypeur*, 23rd year, No.2, column 65 (Nürnberg June 1910).

101 *Ibid*. Columns 77 and 78.

102 *Der Stereotypeur*, No.1 (Nürnberg 1911).

103 Copy of the contract in the Heimatmuseum in Siegburg.

104 Copy in the Heimatmuseum in Siegburg.

105 *Ibid*.

106 *Ibid*.

107 *Ibid*.

108 *Ibid*.

109 Letter dated 6 December 1955.

110 Letter from Albert & Cie to the author dated 21 March 1956.

111 German patent DRP 241374 of 13 October 1910.

112 Letter from Albert & Cie dated 21 March 1956.

113 Detail from *Freiburger Zeitung* (May 1910).

114 Letter from Brend'amour Simhart dated 9 February 1956.

115 Letter from Brend'amour Simhart dated 24 February 1956.

116 Letter from Albert & Cie dated 2 March 1956.

117 Verbal information from Mr A. H. Lockington.

118 George Allen, the publisher of Ruskin's works (later Allen & Unwin), London.

119 Raoul M. Pelissier, later Director of Gravure Foundation of America, which published a gravure handbook by Pelissier in 1933.

120 A steel engraving press with a square table which rotated to allow subsequent inking, cleaning, wiping and printing of the engraved plates from the same working position.

121 From the books of John Wood (Engineers) in Ramsbottom.

122 Letter dated 2 January 1956.

123 Letter from Mr H. N. Beams, Director of Vandyck Printers Ltd, Bristol of 21 December 1953.

124 *Penrose's Pictorial Annual*, Volume XI (1907–8), page 87.

125 *The Process Engraver's Monthly* (December 1907), page 283.

126 From the books of John Wood (Engineers) Ltd, Ramsbottom.

127 *The Process Engraver's Monthly* (June 1910).

128 Thomas Huson. *Photoaquatint and Photogravure*, Dawbarn & & Ward Ltd (London 1897).

129 Charles William Saalburg describing the methods used at the Van Dyck Company, New York, in articles in several contemporary trade papers.

130 Verbal information during a lunch in Mr Edward Hunter's house in London on 15 February 1956 in the presence of Mr A. J. Hughes and Mr Charles Cook, his Co-Directors of the Sun Engraving Company, London.

131 J. J. Waddington in Croydon.

132 From the books of John Wood (Engineers) Ltd.

133 Paper read by Mr A. C. Larcombe to the Sun Study Group, Watford (10 March 1958).

134 Inset captioned 'Busheygram from Andre & Sleigh, Bushey, Herts.' in *The Imprint* (June 1913).

135 The author studied and indexed the file of the beginning of gravure at the *Illustrated London News*, 1912 to 1914, by permission of the then Managing Director General, Sir Bruce Ingram. The file is now in the Science Museum, London.

136 Machine No.18 of Société Alsacienne de Constructions Mécaniques (SACM) in Mulhouse.

137 Machine No.27 of SACM.

138 *Home Words*, edited by the Reverend Charles Bullock according to information in a letter from Mr C. C. Fleming, Director of Butler & Tanner in Frome, Somerset, dated 21 November 1955.

139 During a visit to Butler & Tanner the Works Director, Mr Larcombe, told the author that prior to the outbreak of the war in 1914 Dr Schöpff of Mertens Tiefdruck GmbH and a Mr Roth came to Frome to give instructions in the use of the Mertens process. Somewhat later a changeover to the Siegburg process was tried without success and after the outbreak of the war further work with gravure was discontinued.

140 Letter from Sir James Waterlow, Director of The Amalgamated Press, London, dated 10 November 1955.

141 Letter from Mr George Card, The Amalgamated Press, dated 30 January 1956.

142 Details in the files of Sir Bruce Ingram at the Science Museum, London.

143 Information from R. Hoe & Co. Inc., New York, in a letter with a drawing of the press, dated 2 May 1961.

144 Details in the files of Sir Bruce Ingram at the Science Museum.

145 Special supplement to the *Illustrated London News* 'The Beauty of Photogravure' dated 8 February 1913.

146 From Sir Bruce Ingram's files. The machine is shown in Fig.24 of R. B. Fishenden's paper *On Machine Photogravure*, Royal Photographic Society (London, 16 March 1915).

147 In Sir Bruce Ingram's file is a relevant letter from Deutsche Tiefdruck GmbH to Mr E. H. Rudd, dated 30 January 1913.

148 The author visited Southend on 13 February 1956 and obtained verbal information from Mr John H. Burrows, Director of the *Southend Standard* and the retired machine minders Messrs. Wiseman, King and Warren.

149 Whole page advertisement in *The Penrose Annual*, Volume 19 (1913–14).

150 The machine is illustrated in a catalogue of printing presses issued by R. Hoe & Co. Ltd in London (no date). The press was designed by Mr E. Crone, later Director of Victory Kidder Machine Co. in London (verbal information from Mr Crone). An identical press was delivered to *The Times* in London in 1914.

151 Mr Wiseman told the author during his visit to Southend on 13 January 1956 that he spent some time at Messrs Penrose & Co. to learn the photographic and etching techniques required to produce the cylinders.

152 Examples of such prints are in the Gutenberg Museum in Mainz.

153 From the files of Sir Bruce Ingram and letter from Mr John H. Burrows dated 20 February 1956, stating that the writ was never received in Southend.

154 Item in the Official Catalogue. International Exhibition for Book production and Graphics (Leipzig 1914). British Section, Printing Processes, Gravure Methods, page 87.

155 *Printing Old and New*. Taylor, Garnett Evans & Co. Ltd, Guardian Printing Works, Manchester, Reddish, London and Liverpool (no date).

156 Fig.22 in R. B. Fishenden's, *On Machine Photogravure*, Royal Photographic Society (London, 16 March 1915).

157 Letter from Mr H. M. Cartwright dated 10 November 1955.

158 Letter from Mr W. G. Meredith dated 19 January 1956.

159 Letters from Mr W. G. Meredith dated 13 and 19 January 1956.

160 Four-page leaflet for Rowntree Cocoa. Outer pages printed in gravure, inner pages letterpress. Copy in the Gutenberg Museum in Mainz.

161 Cecil P. Clarke. The story of the beginnings of gravure printing at Clarke & Sherwell. Enclosure to letter from Mr Clarke dated 4 January 1956.

162 Letter from Mr Cecil P. Clarke dated 6 January 1956 with the photograph of the press.

163 J. S. Mertle. Evolution of Rotogravure, Part 14. *Gravure* (December 1956).

164 Edward A. Walz, born 14 November 1864 in Philadelphia, died 6 April 1939 in Overbrook, Pennsylvania.

165 The print is preserved in the Mertle Collection now at the 3M Co., Minnesota Mining and Manufacturing Company.

166 Pictured in *The Penrose Annual*, Volume 33 (1931), page 164.

167 *Print and Progress*, Volume 2, page 41.

168 Letter from Mrs Hermann (Lilli) Horn, Augsburg, dated 3 August 1956.

169 Information from the Free Library, Philadelphia.

170 Charles William Saalburg, born 28 November 1884 in San Francisco. Saalburg's career has many similarities to Karl Klic's. Details in J. S. Mertle. Evolution of Rotogravure, Part 14. *Gravure* (December 1956).

171 Unfinished manuscript by Epstean in the Mertle Collection at the 3M Company.

172 Messrs Ernest Hampton, Richard Whiteside, A. C. Larcombe, L. T. A. Robinson and W. F. D. Fawcett.

173 See page 43.

174 Mr Gamble's statement in the witness box in a lawsuit in London 1925. Van Dyck Gravure Company and Bidart Machinery Corporation against Neo Gravure Printing Company Inc.

175 J. S. Mertle. Evolution of Rotogravure, Part 15. *Gravure* (January 1957).

176 Letters from Mr Frederic D. Murphy of December 1956 and January 1957.

177 J. S. Mertle. Evolution of Rotogravure, Part 17. *Gravure* (February 1957).

178 Information from Corkett's son, Mr E. O. Corkett, January 1956.

179 Stephen H. Horgan, born 1854. Co-inventor of the halftone process. See Louis Walton Sipley, *The Photomechanical Halftone*. American Museum of Photography (Philadelphia 1958), page 15.

180, 181. Letter from Frederic D. Murphy dated 7 December 1955.

182 Letter from Frederic D. Murphy dated 11 January 1956.

183 Letter from Mr S. C. Allyn, President of the National Cash Register Company, Ohio, dated 27 January 1956.

184 Press No.17 from SACM. Extensive documentation with drawings and photographs of early gravure presses built by SACM in Mulhouse was supplied by the Technical Director, Mr Laederich, in correspondence between February and December 1956.

185 Letter from Maschinenfabrik Johannisberg in Geisenheim dated 6 January 1956.

186 See: 'First and Foremost in Rotogravure Advertising'. Brochure issued by *The New York Times* in 1932. Copy in the St Bride's Printing Library in London.

187, 188. Letter from R. Hoe & Co. Inc., New York, dated 2 May 1961 with a list and diagrams of the early gravure presses built by the New York Hoe Company up to 1920.

189 J. S. Mertle. Evolution of Rotogravure, Part 18. *Gravure* (March 1957).

190 Aller received the Machine No.3 from SACM on 19 March 1908.

191 Machine No.59 from SACM delivered 27 July 1914.

192 Letter from Nordisk Rotogravyr dated 20 June 1961.

193 Machine No.51 from SACM delivered 4 November 1913.

194 Machine No.14 from SACM delivered December 1910.

195 Machines Nos.28 and 30 delivered March and April 1913.

196 Machine No.41 from SACM delivered September 1913.

197 Machine No.32 from SACM delivered June 1913.

198 Machines Nos.33 and 34 delivered August 1913.

199 Signature on the printed announcement of the formation of the Tiefdruck Syndikat of November 1913.

200 Machines Nos.15 and 16 from SACM delivered January 1911.

201 Machines Nos.43, 49 and 50 delivered October and 12 and 24 December 1913.

202 Machines Nos.24, 25, 38, 45 delivered July 1912 and July and September 1913.

203 Machine No.47 from SACM delivered 19 January 1914.

204 Machine No.54 from SACM delivered 19 March 1914.

205 Machine No.55 from SACM delivered March 1914.

206 Letters from Mr Wilhelm Bretag dated 26 March and 9 April 1956.

207 Copy in the Landesbibliothek in Berne.

208 File of *Schweizer Illustrierte Zeitung* in the Landesbibliothek in Berne.

209 Machine No.23 from SACM delivered September 1912.

210 *Jean Luginbuhl 1883–1949*. Privately printed.
E. Desfosses-Neogravure (Paris, no date).

211 Machine No.29 from SACM delivered July 1913.

212 Machine No.29 from SACM delivered June 1913.

213 Machine No.39 from SACM delivered September 1913.

214 Machine No.36 from SACM delivered August 1913.

215 Machine No.52 from SACM delivered 8 January 1914.

216 Letter from Albert & Cie, Frankenthal, dated 21 March 1956 and letter from Dr H. J. A. de Goeij, N. V. Drukkerij de Spaarnestad, Haarlem, dated 3 October 1956, stating that the press was sold for scrap in 1930 or 1931.

217 Letter from Nederlandsche Rotogravure Maatschappij in Leiden dated 8 June 1956.

The world's gravure plants up to 1920

The year given after the name of the firm indicates when the first gravure was installed. If known the supplier of the press is indicated as follows:

A Albert & Cie, Frankenthal, reel fed press
AP Albert & Cie, Frankenthal, Palatia sheet fed cylinder press
AW Albert & Cie, Frankenthal, Walküre flat bed machine
E The firm's own design
F Joseph Foster & Sons, Preston
HL R. Hoe & Co. Ltd, London
HN R. Hoe & Co. Inc., New York
J Maschinenfabrik Johannisberg, Geisenheim, reel fed press
JL Maschinenfabrik Johannisberg, Geisenheim, sheet fed press
KBl Kempe-Blecher, sheet fed cylinder press
M Société Anonyme de Constructions Mécaniques, Mulhouse
P Pickup & Knowles, Manchester
U Modified lithographic stone press
W John Wood (Engineers), Ramsbottom

I England

Allen & Co.	London	1908	W
Amalgamated Press Ltd	London	1916	HN
Anglo Engraving Company	London	1911	W
Bemrose & Sons	Derby	1910	W
Butler & Tanner	Frome	1911	M
Clarke & Sherwell	Northampton	1914	AP
Richard Clay & Sons	London	1916	HN
Iliffe & Sons	Coventry	?	KBl
Illustrated London News	London	1912	J
Intaglio Patents Ltd	London	1912	M
George Newnes	London	1909	M
Rembrandt Intaglio Printing Company	Lancaster	1895	F
Sanderson Wallpapers	London	1919	P
Southend Standard	Southend	1913	HL
J. Swain & Co.	London	?	?
Swan Electric Engraving Company	London	1911	W
Taylor Garnett Evans & Co.	Manchester	1911	E
The Times	London	1913	HL
Vandyck Printers Ltd	Bristol	1912	W

II France

Crété	Corbeil	1913	M
Deplanche Falk & Cie	Montrouge	1913	M
Auguste Godchaux & Cie	Paris	1864	E
L'Eclair de Montpellier	Montpellier	1913	M
L'Illustration	Paris	1910	M
Le Nouvelliste de Lyon	Lyon	1919	M
Petit Parisien	Paris	1913	M
La Photogravure Rotative	Paris	1913	M

III Germany

Brend'amour Simhart & Co.	Munich	1912	AW, AP
F. Bruckmann	Munich	1904	W
Deutsche Photogravur A.G.	Siegburg	1907	M
Deutsche Tageszeitung	Berlin	1915	?
Otto Elsner	Berlin	1913	M
Fischer & Wittig	Leipzig	1914	A
Frankfurter Sozietätsdruckerei	Frankfurt	1910	M
Freiburger Zeitung	Freiburg	1910	M
W. Girardet	Essen	1913	M
Graphische Gesellschaft	Berlin	1904	M
Dr. Haas'sche Buchdruckerei	Mannheim	1912	KBl
Hamburger Fremdenblatt	Hamburg	1910	M
Carl Lange	Duisburg	1913	M
Meisenbach Riffarth & Co.	Berlin	1906	U
Dr Mertens Laboratorium	Freiburg	1908	M
Mertens Tiefdruck GmbH	Mannheim	1913	M
Rudolf Mosse	Berlin	1912	M
Pass und Garleb	Berlin	1913	M

Pick & Co.	Munich	1912	KBl
Rohr, Graphische Kunstanstalt	Berlin	1913	A
Rotophot GmbH	Berlin	1910	KBl
Dr Selle & Co.	Berlin	1912	KBl
Ullstein A.G.	Berlin	1912	KBl
W. Vobach	Leipzig	1914	?
J. J. Weber	Leipzig	1912	KBl

IV Russia

Kopeika	St Petersburg	1912	KBl
A. A. Levenson	Moscow	1913	KBl
Constantin de Nesluchowsky	St Petersburg	1914	M
S. M. Propper	St Petersburg	1911	M
J. D. Sytin	Moscow	1912	KBl
Wilhelm und Hermann Welfers	Moscow	1910	U

V United States of America

Alco Gravure	New York	?	?
American Photogravure Company	Philadelphia	1904	W
Boston Herald	Boston	1913	J
Chicago Tribune	Chicago	1913	J
Cleveland Plain Dealer	Cleveland	1914	J
Curtis Publishing Company	Philadelphia	1913	J
Detroit News	Detroit	1918	HN
Metropolitan Arts Craft Co.	New York	1919	HN
New York American	New York	1917	HN
New York Sun	New York	1912	HN
New York Times	New York	1913	J
Photogravure Company of America	Philadelphia	1906	?
Public Ledger	Philadelphia	1914	J
Regensteiner Color Type Co.	Chicago	1913	J
Rotary Photogravure Company	Passaic	1905	?
Sackett & Wilhelms	New York	1913	J
St Louis Despatch	St Louis	1919	HN
Times–Mirror	Los Angeles	1916	HN
Van Dyck Gravure Company	New York	1905	?

VI Other Countries

Australia			
Sydney Sun	Sydney	1916	HN
Austria			
J. Loewy, k.u.k. Kunstanstalt	Vienna	1906	W
Österreichische Zeitungs-druckerei A.G.Karl Groag	Vienna	1913	M
Belgium			
van Dosselaere	Ghent	1913	M
Canada			
Grip	Toronto	1914	J
Denmark			
Carl Aller	Valby	1908	M
Egmont H. Petersen	Copenhagen	1914	M
Holland			
Nederlandsche Rotogravur Maatschappij	Leiden	1913	J
Drukkerij de Spaarnestad	Haarlem	1914	A
Hungary			
Athenaeum	Budapest	1914	M
Poland			
Drukarnia i Ksiegarnia	Posnan	1912	KBl
South America			
La Discussion	Habana	1915	?
Empresa Zig Zag	Santiago	1915	?
Excelsior Newspaper	Mexico City	1918	M
Imprentia Soc. Universo	Valparaiso	1912	KBl
Spain			
La Tribuna, El Dia Grafico	Barcelona	1913	M
Prensa Espagnola	Madrid	1913	M
Sweden			
Ahlen & Akerlund	Stockholm	1916	J
Ehrnfried Nyberg Boktrykare	Stockholm	1913	M
Nordisk Rotogravur	Stockholm	1918	M
Switzerland			
SADAG	Geneva	1912	M
Ringier	Zofingen	1914	A
Haefeli & Co.	La Chaux de Fonds	1920	JL

Bibliography

The following list does not claim to be exhaustive. It contains only the earliest books and from later publications those which are most important from the techno-historical point of view.

Albert, Prof. August
Neuere Heliogravüreverfahren.
Photographische Korrespondenz (Vienna 1906), page 338.

Albert, Prof. August
Ein neues Illustrationsverfahren für Zeitungen.
Paper read to the k.u.k. Photographische Gesellschaft (Vienna, 12 April 1910).

Albert, Prof. Karl
Ein Beitrag zur Geschichte des Rakeltiefdruckes in Amerika.
Photographische Korrespondenz, Volume 63, No.7 (Vienna 1927).

Albert, Prof. Karl
Karl Klietsch, der Erfinder der Heliogravure und des Rakeltiefdrucks.
Graphische Lehr- und Versuchsanstalt (Bundesanstalt) (Vienna 1927).

Albert, Prof. Karl
The Beginnings of Rotogravure in America.
Penrose's Annual, Volume 30, Lund Humphries (London 1928).

Albert, Prof. Karl
The History of Rotogravure in America.
Penrose's Annual, Volume 35, Lund Humphries (London 1931).

Anglo Engraving Co. Ltd
Whole page advertisement for 'Machine Printed Rotary Photogravure'.
Penrose's Pictorial Annual, Volume 16, Back end paper
Lund Humphries (London 1911–12).

Anon
Sculptura-Historico-Technica or the History and Art of Ingraving.
S. Harding, on the Pavement in St Martin's Lane (London 1747).

Anon
The History of Printing.
Society for Promoting Christian Knowledge (London 1855).

Anon
Vom Mertens'schen Rotationstiefdruck.
Die Photographische Industrie (1910), page 1326.

Anon
Zwei bemerkenswerte Rotationstiefdruckmaschinen.
Klimsch Jahrbuch (1914), page 239.

Anon
Intaglio Process, Marvel of Printing.
American Photo Engraver (March/April 1914).

Anon
Karla Klic, Listopad Prosniec.
Catalogue of the Memorial Exhibition for Karel Klic (Prague 1929).

Anon
Jean Luginbuhl 1883–1949. In Memoriam
Privately printed, E. Desfosses-Neogravure (Paris, no date).

Anon
Karel Klic, Vynalezce Hlubotisku.
Orbis (Prague 1957).

Baudry, Georges
Helio, Gravure et Tirage.
Ministère de l'Education Nationale, Institut National des Industries et Arts Graphiques (Paris 1947).

Blecher, Carl
Beitrag zur Theorie der Heliogravureätzung.
Zeitschrift für Reproduktionstechnik, No.12 (1905).

Blecher, Carl
Lehrbuch der Reproduktionstechnik.
Wilhelm Knapp Verlag (Halle 1908).

Blecher, Carl
Beiträge zur Geschichte und Technik des Schnellpressen-Tiefdruckes.
Der Stereotypeur, No.3 (1910); No.4 (1910).

Blecher, Carl
Das Wesen des Tiefdruckes.
Zeitschrift für Reproduktionstechnik, Nos.1 and 2 (1911).

Bosse Kupfferstecher zu Parisz in Frankreich.
Kunstbüchlein handelt von der Radier- und Etzkunst.
Gedruckt durch Heinrich Pillenhofer.
In *Verlegung Paulus Fürsten, Kunsthändlern* (Nürnberg 1652).

Brandweiner, Adolf
Photographisches Verfahren zur Herstellung von Druckwalzen für
Stoffdruck.
Photographische Korrespondenz, No.1 (Vienna 1892). page 1.

Braun, Alexander
Der Tiefdruck, seine Verfahren und Maschinen.
Polygraph Verlag (Frankfurt am Main 1952).

Brückner, Max
Der Mertenstiefdruck und seine Bedeutung als
Universalillustrationsmittel.
Klimsch Jahrbuch (1911), page 254.

Cartwright, H. M.
Photogravure.
American Photographic Publishing Company (Boston 1939).

Cartwright, H. M. and Robert MacKay
Rotogravure
MacKay Publishing Company Inc. (Lyndon, Kentucky 1956).

Courmont, E.
La Photogravure, Histoire et Technique.
Gauthier-Villars, Imprimeur-Editeur (Paris 1947).

Denison, Herbert
A Treatise on Photogravure in Intaglio by the Talbot-Klic Process.
Iliffe & Son (London, no date (1893)).

Dijk, F. van
L'héliogravure rotative.
Le procédé (Paris 1917).

Duchaine, Aîné
Essai sur Nielles.
Merlin Libraire (Paris 1826).

Eder, Hofrat, Dr Josef Maria
Ausführliches Handbuch der Photographie. Volume 1, 2 parts,
Geschichte der Photographie.
Verlag Wilhelm Knapp (Halle (Saale) 1932).

Eder, Hofrat, Dr Josef Maria
Ausführliches Handbuch der Photographie. Volume 4, 3rd part,
Heliogravure und Rotationstiefdruck.
Verlag Wilhelm Knapp (Halle (Saale) 1922).

Emmerich, Prof. G. H.
Lexikon für Photographie und Reproduktionstechnik.
Chapters on *August Albert, Druckverfahren, Heliotinto-Verfahren,
Intaglio-Verfahren, Karl Klic, Kupferschnellpressentiefdruck,
Dr Eduard Mertens, Mezzotinto-Verfahren, Rembrandtdruck, etc.*
A. Hartleben Verlag (Vienna 1910).

Falke, Jacob von
Farbige Kupferstiche.
Photographische Korrespondenz, No.377 (Vienna 1892), page 70.

Felsburg, F.
Die photomechanische Reproduktion im Dienste des Stoffdrucks.
Klimsch Jahrbuch (1902), page 176.

Felsburg, F.
Die photomechanischen Verfahren im Stoff- und Tapetendruck.
Klimsch Jahrbuch (1904), page 233.

Fishenden, R(ichard) B(ertram)
Printing methods in relation to the photomechanical processes.
Penroses' Pictorial Annual, Volume 9 (1905–6), page 87.

Fishenden, R. B.
Some experiments towards rotary intaglio printing.
Penrose's Pictorial Annual, Volume 16 (1910–11), page 153.

Fishenden, R. B.
Rotary Intaglio Printing and Machine Printed Photogravure.
British Colonial Printer and Stationer (28 November 1912).

Fishenden, R. B.
Intaglio and Rotary Photogravure.
British Journal of Photography (1913), page 455.

Fishenden, R. B.
On Machine Photogravure.
Royal Photographic Society (London 1916).

Gamble, William
The Year's Progress.
Penrose's Pictorial Annual, Volume 16 (1910–11), page 6;
Volume 18 (1912–13), page 2; Volume 19 (1913–14), page 2.

Gamble, William
Position and Prospects of Process Work.
Penroses' Pictorial Annual, Volume 21 (1916), page 12.

Gasch, Bernard
Rakeltiefdruck.
Verlag Wilhelm Knapp (Halle (Saale) 1950).

Gernsheim, Helmut and Alison
The History of Photography.
Oxford University Press (1955).

Gesierich, Franz
Wiener Tiefdruck (Intaglio). Zur Ehrung Theodor Reichs.
Staatl. Graphische Lehr- und Versuchsanstalt (Vienna 1946).

Goldberg, Prof. E(manuel)
Die Grundlagen der Reproduktionstechnik.
Encyklopädie der Photographie, Volume 80,
Verlag Wilhelm Knapp (Halle 1912).

Hartmann, Rene
Rolff's Photogravureverfahren für Druckwalzen.
Zeitschrift für Textil- und Farbchemie (1902), page 542.

Horgan, Stephan H.
Inventor of Rotary Photogravure (short biography of Klic).
Penrose's Pictorial Annual, Volume 19 (1913–14), page 110.

Husnik, J.
Die Heliographie.
A. Hartleben Verlag (Vienna 1905).

Huson, Thos.
Photoaquatint and Photogravure.
Dawbarn & Ward (London 1897).

Internationale Tiefdruckausstellung
Katalog.
Kunstgewerbemuseum (Prague, November/December 1912).

Isaacs, George A.
The Story of the Newspaper Press.
Co-operative Printing Society Limited (London 1931).

Jackson, John
A Treatise on Wood Engraving, Historical and Practical.
Charles Knight & Co., Ludgate Street (London 1839).

Kampmann, C.
Die Graphischen Künste.
Sammlung Göschen, Volume 75.
G. J. Göschen'sche Verlagshandlung (Leipzig 1905).

Kasper and Bindewald
Bunter Traum auf gewebtem Grund.
Georg Westermann Verlag (Brunswick 1950).

Kempe, Hermann
Tiefdruck.
Der Stereotypeur, No.2 (Nürnberg 1910).

Kempe, Hermann
Die Kempe-Tiefdruck-Schnellpresse (System Blecher).
Der Stereotypeur, No.3 (Nürnberg 1910).

Kempe, Hermann
Die Entwicklung des Tiefdruckes in den letzten Jahren.
Der Stereotypeur, Nos.1 and 2 (Nürnberg 1912).

Kempe, Hermann
Der Schnellpressentiefdruck an der Wende des Jahres 1912.
Der Stereotypeur, No.4 (Nürnberg 1912).

Kempe, Hermann
Der Schnellpressentiefdruck.
Der Stereotypeur, Nos.1 and 2 (Nürnberg 1913).

Klimsch & Co.
Künstlerliste
(Frankfurt am Main 1905.)

Klimsch, E(ugen)
Mertensdruck und ähnliche Tiefdruckrotationsverfahren.
Paper read to the Verein zur Pflege der Photographie (Frankfurt-am-Main 1910).

Lamey, F.
La Photogravure Rotative, Historique, Procédé, Formules.
Librairie Hachette, Paris (Mulhouse 1924).

Lamp, Charles
Manuale pratico di rotocalco.
Editoriale Pubblicitaria internazionale srl. (Milan 1955).

Lascelles, T. W.
Rotary Photogravure.
Penrose's Pictorial Annual, Volume 21 (1916), page 17.

LeBlon, J. C.
L' Art d'Imprimer les Tableaux, 2nd edition.
Edited by Gautier de Mondorge (Paris 1756).

Lecuyer, Raymond
Histoire de la Photographie.
Bascher & Cie (Paris 1946).

Leech, Miriam and Cook, Charles F.
David Greenhill, Master Printer
Published privately. Sun Printers Ltd (Watford 1950).

Lehmann, E.
Theorie und Praxis der Heliogravüreätzung.
Zeitschrift für Reproduktionstechnik (1907), page 55.

Leiber, F.
Tiefdruckillustrationen mittels Rotationstiefdruck.
Zeitschrift für Reproduktionstechnik (1910), page 82.

Longhi, J.
Die Kupferstecherei oder die Kunst, in Kupfer zu stechen und zu ätzen.
Translated by C. Barth.
Verlag der Kesselringschen Hofbuchhandlung (Hildburghausen
and Meiningen 1837).

Mente, Prof. O(tto)
Über Rakeltiefdruck.
Klimsch Jahrbuch, Volume 19 (1914), page 9.

Mente, Prof. O.
Hoch- und Tiefdruck in der modernen Zeitungsillustration.
Technische Rundschau (Berlin 1913), page 234.

Mertle, J. S.
Evolution of Rotogravure.
20 parts. *Gravure* (Garden City, New York November 1955 to
June 1957).

Meusser, Dr A.
Photomechanischer Rakeltiefdruck.
Zeitschrift für Reproduktionstechnik (1912), pages 82, 119, 137.

Meyer, Bruno
Tapetendruck auf photographischem Wege.
Die Photographische Industrie (1906), page 528.

Mittenberger, Martin
Handbuch des Tiefdruckes.
Verlag Deutscher Drucker (Berlin 1935).

Mosse, Rudolf
*Festschrift zur Feier des fünfzigjährigen Bestehens der
Annoncen-Expedition* (Berlin 1917).

Mundinger, Emil
Zur Geschichte des Tiefdrucks.
Siegwerk Farbenfabrik Keller, Dr Rung & Co. (Siegburg 1957).

Nefgen, Dr A(ugust)
Der Rotationstiefdruck.
Der Stereotypeur, Nos. 1 and 2 (Nürnberg 1912).

Pellissier, M. Raoul
Photogravure.
American Annual of Photography (1916).

Pfeiffer-Belli, Erich
100 Jahre Bruckmann.
F. Bruckmann KG (Munich 1958).

Philip, George
The Story of the House of Philip during the last 100 years.
George Philip & Sons Limited (London 1934).

Rolffs, Ernst
Dreifarbendruck auf Geweben.
Zeitschrift für Farben- und Textilindustrie.
Fr. Vieweg-Verlag (Brunswick 1903), page 221.

Rolffs, Ernst
Zur Geschichte des Tiefdruckes.
Official catalogue. Ausstellung für Buchgewerbe und Graphik
(Leipzig 1914).

Russ, R.
Von den Neuerungen der Reproduktionstechnik.
Klimsch Jahrbuch (1913), page 274.

Schlosser, Hermann
Den Freunden unseres Hauses.
Sondernummer der Hauszeitschrift Burda-Familie.
Burda Druck und Verlag (Offenburg, no date (1958?)).

Schrott, Dr Paul von
Rotationstiefdruck.
Archiv für Buchgewerbe (1910), page 136.

Schrott, Dr Paul von
Über photomechanischen Rotationsdruck.
Eders Jahrbuch für Photographie und Reproduktionstechnik (1910),
page 233.

Stapart, M.
L'Art à Graver au Pinceau, Nouvelle Méthode.
(Paris 1773.)

Strakaty, Adalbert
Der Rakeltiefdruck.
Privately published (Mauthausen 1955).

Swan, Cameron
Pioneers of Photogravure.
The Imprint (London, June 1913).

Swan Electric Engraving Company
*Specimens of Reproduction, Press Opinions and some Criticisms of
well-known Artist on the Work of the . . .*
(London 1895).

Swan, Sir Kenneth R.
Sir Joseph Swan and the invention of the incandescent lamp.
Longmans Green & Co. for The British Council (London 1946).

Taylor, Garnett, Evans & Co. Ltd
Printing Old and New.
Guardian Printing Works (Manchester, no date (1912 ?)).

The Times
Printing Number.
(London, 10 September 1912).

The Times
Printing in the Twentieth Century.
Reprinted from The Special Number of *The Times*, 29 October
1929 (London 1930).

Toifel, Wilhelm F.
Handbuch der Chemigraphie.
A. Hartleben Verlag (Vienna 1896).

Volkmer, Otomar
Die Photo-Gravure zur Herstellung von Tiefdruckplatten.
Wilhelm Knapp (Halle (Saale) 1895).

Wende, Bernhard
Tiefdruck.
Handbuch der modernen Reproduktionstechnik, Volume 4.
Klimsch & Co. (Frankfurt am Main 1938).

Wilke, R.
Fortbildung des Rakeltiefdruckes.
Zeitschrift für Reproduktionstechnik (1916), page 25.

Wilke, R.
Zur Geschichte des Rakeltiefdruckes mit photomechanisch
hergestellten Druckformen.
Zeitschrift für Reproduktionstechnik (1916), page 50.

Wood, Franklin
Photogravure, Printing Theory and Practice.
Sir Isaac Pitman & Sons Ltd (London 1949).

Index

DATE DUE

DATE DUE			
NOV 0 '83			
GAYLORD			PRINTED IN U.S.A.

Has Anyone Seen Woodfin?

By Susan Egner

Illustrations by A.J. Dewey

HAS ANYONE SEEN WOODFIN?

ISBN: 0-9711711-1-4
LCCN: 2002104024

Manufactured in Hong Kong by Norman Graphic Printing
Designed by Tom Maakestad, Marine on St. Croix, MN

Woodfin is a fantasy character based on a real creature, the anole, a small lizard found in the southeastern United States. With the ability to change its color to brown or green, it is called the "American chameleon."

To Judy Johnson, my best friend for thirty years.
Thank you for living up to the definition of a true friend.
I look forward to the next thirty.
Susan

To my very colorful Orange Grandma,
with much love,
A.J.

"Has anyone seen Woodfin?" asked Leafin the chameleon in her high voice. "Has anyone seen my brother?"

"I saw him on the lilacs," said Clipper the cardinal.

"In other words, he was purple," grumbled Leafin.

"He called it amethyst," replied Clipper as he adjusted his aviator goggles.

"Pardon me," said Charles, the very proper woodchuck. "But I'm sure I saw Woodfin in a pile of poplar leaves by the stream."

"Was he yellow?"

"He called it ochre," said Charles as he straightened his bow tie. "Ochre, might I remind you, is a nice warm yellow."

A young chameleon named Lapis said, "I saw him on some geraniums."

"And what did he call that color?" asked Woodfin's sister.

"Red," replied Lapis. The Chatterpillars nearby laughed.

"Mother's going to have a fit if she finds him red . . . or purple again." She looked around frantically.

"Leafin, Woodfin is special," said Clipper. "He likes being different colors."

"And stripes and polka dots and plaid!" chimed in the other animals.

"Well, he's supposed to be green or brown," said Leafin, snapping her tail in exasperation. "We're chameleons and those are the only colors we should be. Our safety depends on it. That way we're camouflaged."

Leafin continued searching for her brother.
A dark shadow passed overhead. She glanced up and saw
Hank the hawk circling above. His beady black eyes
searched the forest for food. He could not see her because
she matched the tree. Where was Woodfin? Could the
hawk see him?

"Woodfin," she shouted. "Where are you?"

"Right here, Leafin," answered Woodfin from right beside her. He so perfectly matched the brilliant blue of a morning glory that she hadn't even seen him.

"Woodfin, Mom's looking for you. And she's not going to be happy if she finds you the wrong color again. Why do you do that?"

"I like these colors. They're different. I like being different." He pressed his nose into the center of the flower and sniffed the sweet scent.

"Have you even tried green or brown?" asked Leafin.

Woodfin dodged the question by jumping

from flower to flower. His colors rippled from blue to the fuchsia of honeysuckle to the rich gold of sunflowers.

Forgetting her mission, Leafin marveled at her brother's kaleidoscope of unchameleon-like colors. For just a moment she was tempted to see if she could match the brilliant colors of honeysuckle.

"Oh, I do like that color," she thought.

But then she remembered what their mother had said: "What if he can't turn green or brown? Will he survive?" A cool breeze rippled through the forest and Leafin felt the first chill of winter. Soon the bright colors of summer would disappear. What would Woodfin match then?

"Come on, Woodfin, let's practice this green on the spruce tree. It's more blue than green, and I did just see you turn blue."

Woodfin jumped to the tree, squeezed his eyes shut, and tried very hard. He opened one eye and peeked at his tummy. It was navy blue. Close, but not close enough. Then he twirled all the other colors of blue.

"Look, Leafin, don't I look great in blue?" he boasted.

"It's not green. Try looking great in green," she said.

Leafin jumped to the trunk of a willow. "Please, Woodfin, try this. This bark is practically yellow and Charles said you turned ochre."

Leafin's voice had changed and she sounded as if she might cry. Even though he'd never tell her, Woodfin actually liked his sister. He didn't want her to cry.

Squeezing his eyes tightly shut, he concentrated on this new color but he was afraid to open his eyes.

"What color am I now?" he asked her.

"Not the right color," she said, shaking her head in alarm. "Any sharp-eyed hawk would see you in a minute. Keep practicing. You don't have much time before winter comes."

They practiced all day but Woodfin never matched the standard chameleon colors.

"I don't know what else to do. We'll have to ask Bach the Croc," said Leafin, shivering at her own suggestion.

"Oh, Leafin, aren't you afraid of Bach the Croc? He may be wise but he's the biggest animal in the forest!"

"I know, but we don't have any other choice," answered Leafin, pulling her brother deeper and deeper into the darkest depths of the forest. Thick moss, draped across the branches, blocked the sun. Ancient trees towered over them, casting frightening shadows that took on monster shapes.

At last they found Bach the Croc napping, submerged in the murkiest part of the swamp, only his eyes above water. "Who disturbs my nap?" his voice rumbled.

"We need your help," pleaded Leafin.

"What's the problem?" asked Bach.

"It's my brother, Woodfin. He can't turn brown or green like other chameleons. What will happen to him in the winter?"

"What colors can he match?" asked Bach, opening his large eyes to study the tiny, off-color chameleon.

"I can match the black and white spots of the loon," shouted Woodfin as he leaped onto the back of a mother loon swimming by.

"Loons go away in the winter," said Bach, shaking his head.

"I don't want Woodfin to go away," cried Leafin.

"I can match the yellow center of a daisy," said Woodfin, peeking out from the flowers that bordered the pond.

"The daisies fade away when the temperature drops," growled Bach.

Leafin persisted, "So what can we do, sir?"

"Aren't there other colors in the forest in winter?" asked Bach. "There will be pumpkins. Can you turn orange, Woodfin?"

"Yes, indeed!" said Woodfin, matching the orange wing of a parrot that had just landed beside him.

"Well, then, that's your answer. He can match the pumpkins," said Bach, closing his eyes.

"The pumpkins will be harvested in the fall," cried Leafin.

"Has a hungry bird seen him this summer?" asked the old Croc. "He stayed safe being himself, didn't he?" Bach watched Woodfin jump from a pink lily to a deep red hibiscus.

"He's very special," said Bach, smiling a toothy smile. "Look at his beautiful colors."

"But that's just it. He matches only the bright colors," explained Leafin. "There are no bright colors in the winter."

Woodfin heard the worried voice of his sister and something inside of him started spinning around. He had never meant to make his family unhappy. As he worried, his body rippled with the many colors of the forest, yellow

and blue and gold and pink and crimson. The colors spun together until they started to blend. Blues and yellows turned into green. Yellows and purples swirled together to make brown.

"I'm doing it! Look everyone, I'm doing it," he said as he twirled through the rainbow of colors, finally stopping at the yellow green of a willow tree's bark.

He leaped to the prickly branches of an evergreen. Again he twirled until his color matched it perfectly.

"Can I still match the orange pumpkin and the red grapes and the blue morning glories?" he asked.

Woodfin's sister looked doubtful. "Mom says chameleons are supposed to be only green and brown."

Just then the big crocodile stirred in the mud. With a crash of his great tail, he declared, "Let Woodfin be himself." And, in the moment before he slid gracefully beneath the black water, Bach delivered his last words on the subject: "Woodfin has shown us he can survive. Let him be what he is . . . a very exceptional chameleon!"